Lit by the Sun

The Art and Artists of the Hotel Pattee

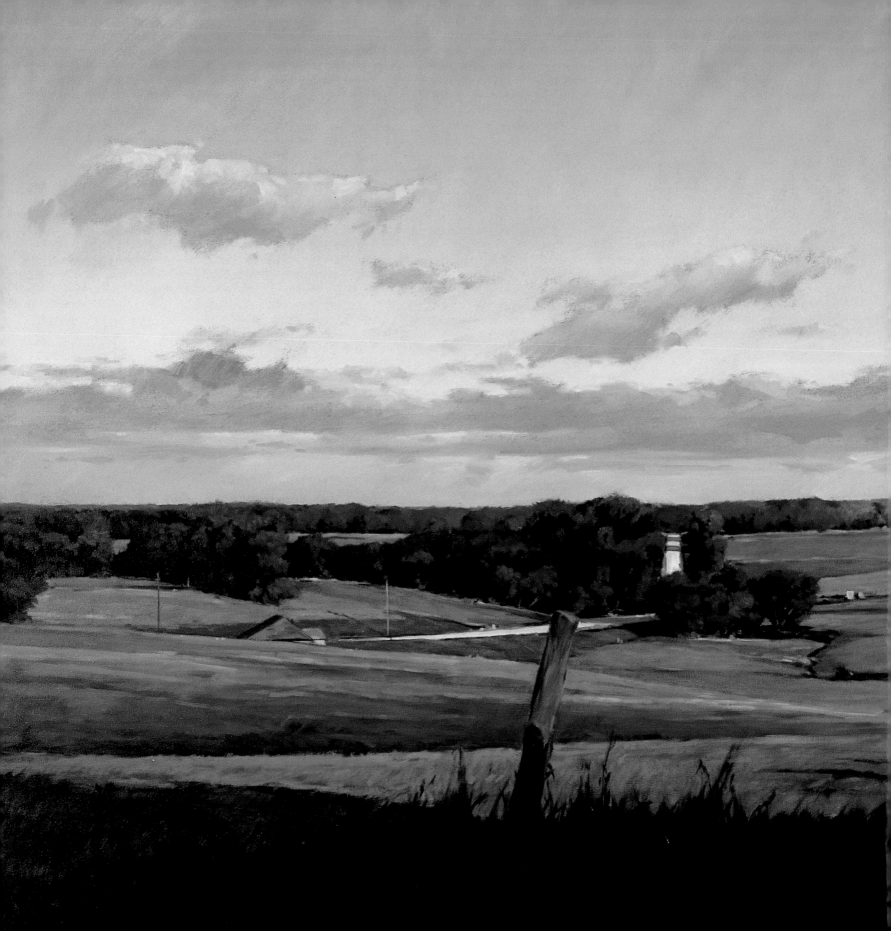

In Iowa the land itself is art,
pattern, texture, and color,
changing with the seasons,
lit by the sun,
rubbed by the clouds,
tossed and reborn with the wind.

— Roberta Green Ahmanson

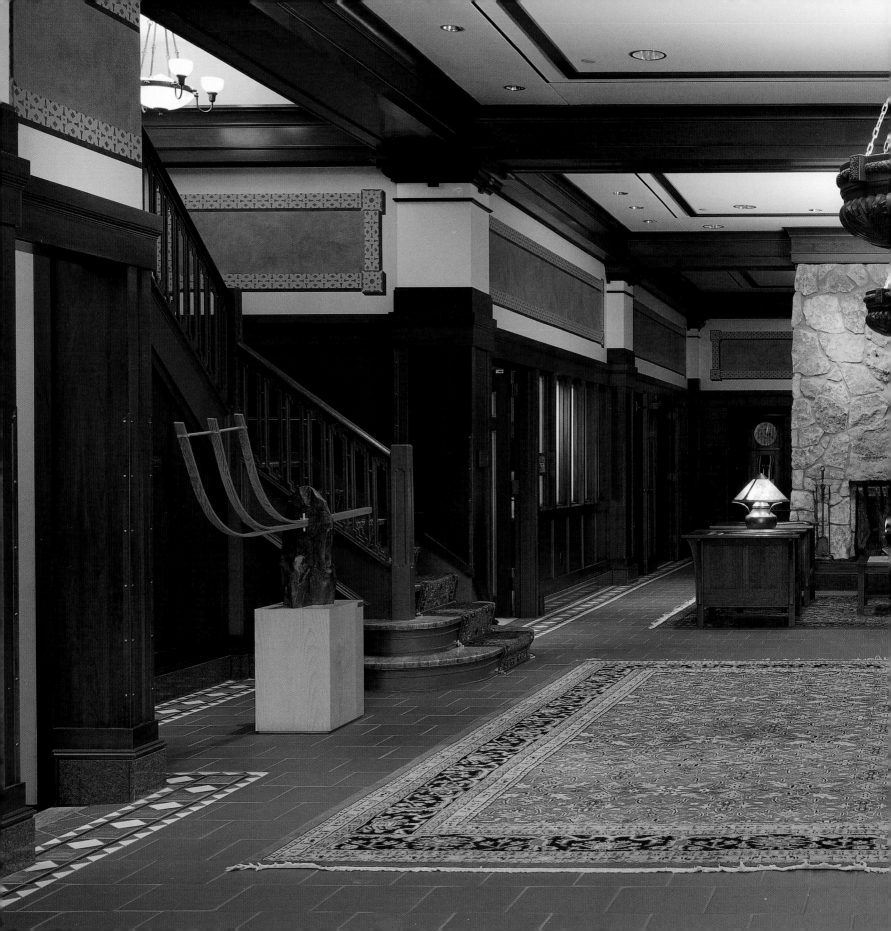

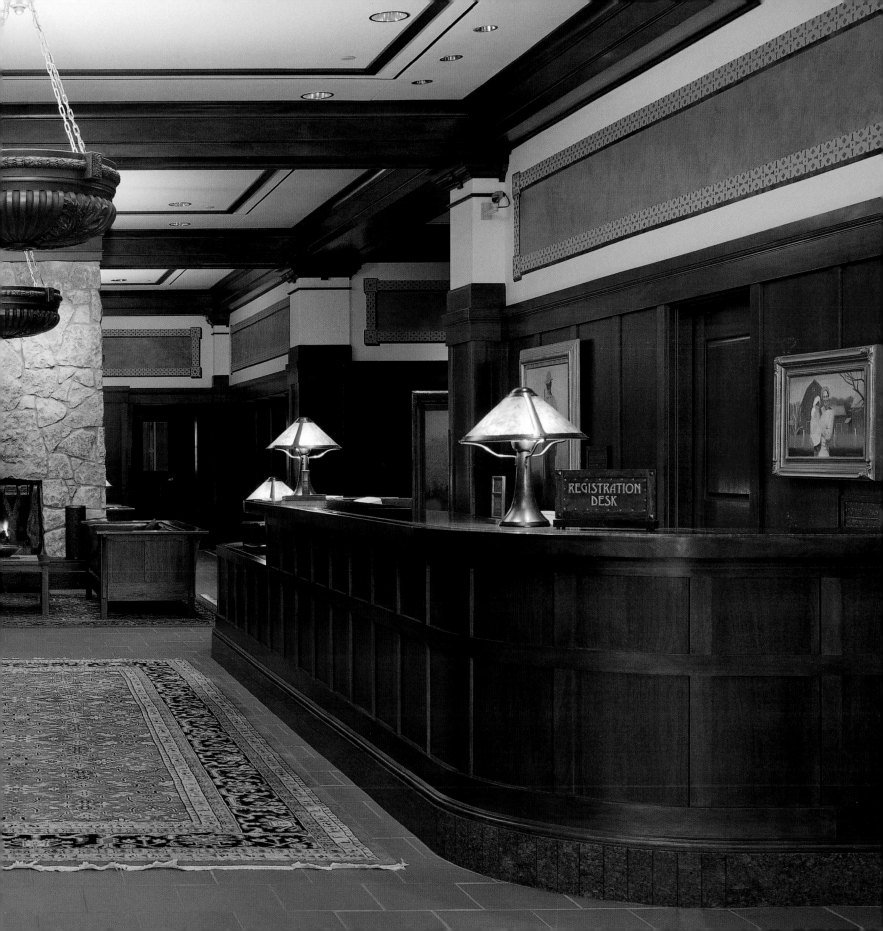

REGISTRATION
DESK

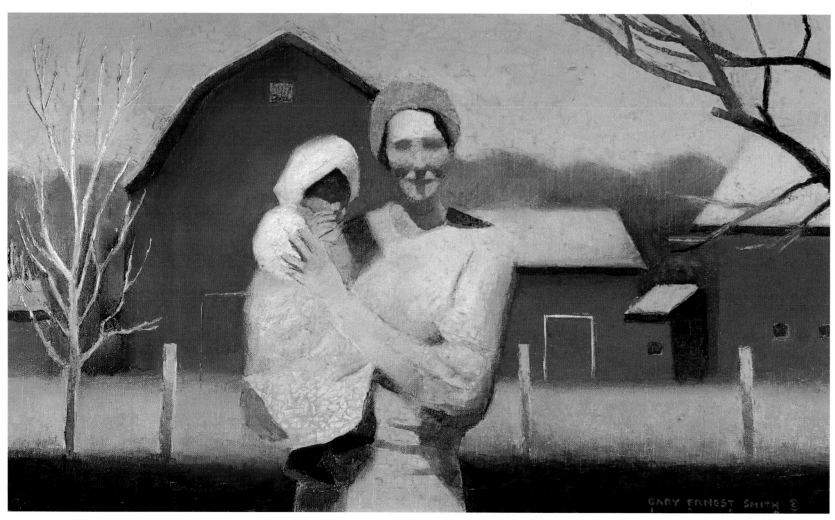

Gary Ernest Smith, *Mother and Child*, 1994
Oil on canvas | 14 x 24 inches

Lit by the Sun

The Art and Artists of the Hotel Pattee

By Lela Gilbert *Photography by* Ellen Bak

Carpe Diem Books

Published by Carpe Diem Books®, Portland, Oregon
 President: Ross Eberman
 www.carpediembooks.com

Lit by the Sun: The Art and Artists of the Hotel Pattee / text by
Lela Gilbert ; photography by Ellen Bak.
ISBN 0-9713555-0-9
Library of Congress Control Number: 2001095247

Book Design: Reynolds/Wulf Design, Inc.
 Robert M. Reynolds, Letha Gibbs Wulf
Production Coordinator: Vicki Gallo
Copy Editor: Linda Gunnarson
Project Coordinator: Ann Hirou
Additional Photography: Jon Jamison (page 38) and Bill Nellans
 (pages 45, 72–73, 107, 150–151)
Assistant to Ellen Bak: Tim Meyer

Printed and bound in Hong Kong

Page 2: John Preston, *Late Summer Morning,* 1997
Oil on canvas | 35 x 47.5 inches

Page 4–5: Hotel Pattee lobby

Page 12–13: Steven Kozar, *Waiting for Grandma,* 1995
Watercolor on paper | 12 x 24 inches

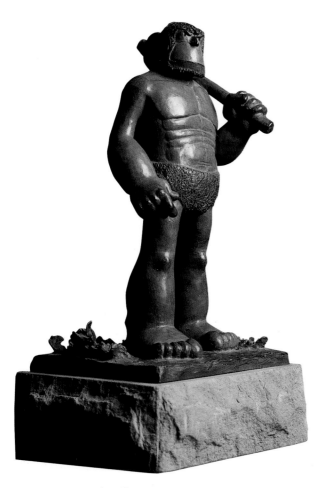

Gary Ernest Smith, *Alley Oop*, 1998
Bronze | 17.25 inches with base

Table of Contents

Preface

Nearly eight years ago, ever since I started thinking about what the Hotel Pattee could be, art was part of the vision. The goal was to celebrate Iowa, its story, and its people in every art form possible.

Since the original hotel was designed with the English Arts and Crafts Movement in mind, it was a natural step to think about how William Morris and his compatriots, founders of that movement, thought about art in relation to architecture and design. For them, it was clear. "Have nothing in your homes which you do not know to be useful or believe to be beautiful," Morris wrote.

His own homes and those he helped design were integrated wholes of the finest art and craftsmanship in everything from the brick- and stonework to the furniture, tiles, textiles, and the paintings and sayings that adorned the walls, the mantelpieces, and the furniture. Of course, the English movement began with a group of painters, the Pre-Raphaelites, so named because they wanted to build their art on the methods and aesthetic vision of artists before the time of the late-Renaissance painter Raphael. William Morris himself tried his hand at painting in the Pre-Raphaelite mode, following others, such as Dante Gabriel Rossetti, Sir Edward Burne-Jones, Sir John Everett Millais, and William Holman Hunt. Morris's goal was to combine the beauty and usefulness of the arts into a coherent, satisfying whole and to honor the craftsmen and women who created it.

Art is deep within all of us. The Christian and Jewish traditions tell us we are created in the image of God, the original Creator, and so we, too, must create. Other traditions identify the origins of art differently, but each has produced powerful visual images, whether in paintings, sculpture, needlework, or illuminated manuscripts.

Iowa has its own tradition. Perhaps its best-known artist is Grant Wood, the man from near Cedar Rapids, famous for his stylized but entrancing interpretations of the Iowa landscape and its people. In Iowa the land itself is art, pattern, texture, and color, changing with the seasons, lit by the sun, rubbed by the clouds, tossed and reborn with the wind.

So, because one purpose of the Hotel Pattee is to celebrate the land and the people of Iowa, it was clear that the art in the hotel should follow that lead. With the help of Kathleen Laurila, original interior designer of the hotel; Marlene Olson of Olson-Larsen Galleries; Bonnie Percival, then of Percival Galleries; Tracie McCloskey of Tracie McCloskey Interiors; and our special projects associate Ann Hirou, I began to look for artists whose work celebrated those themes.

Today the Hotel Pattee is honored to share the work of more than thirty artists, most of them from Iowa or the Midwest. Their work is an example of that image-of-God creativity we all possess and of the legacy of Iowa, the beautiful land. Now, with the help of Lela Gilbert and Ellen Bak, it is my joy to share their work with you.

Roberta Green Ahmanson
President, Pattee Enterprises
22 May 2001

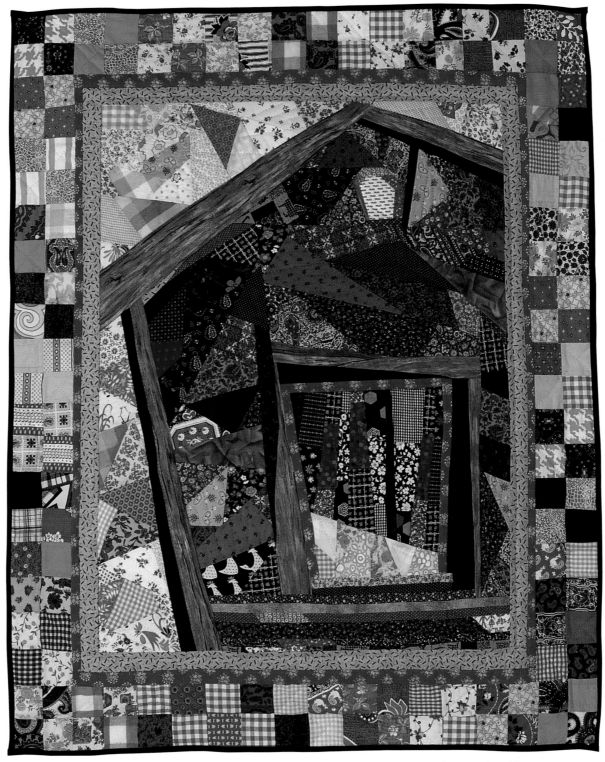

Murray Johnston, *The Old Barn Door*, 2000
Quilt made from old feed sacks and contemporary cotton fabric | 36 x 44 inches

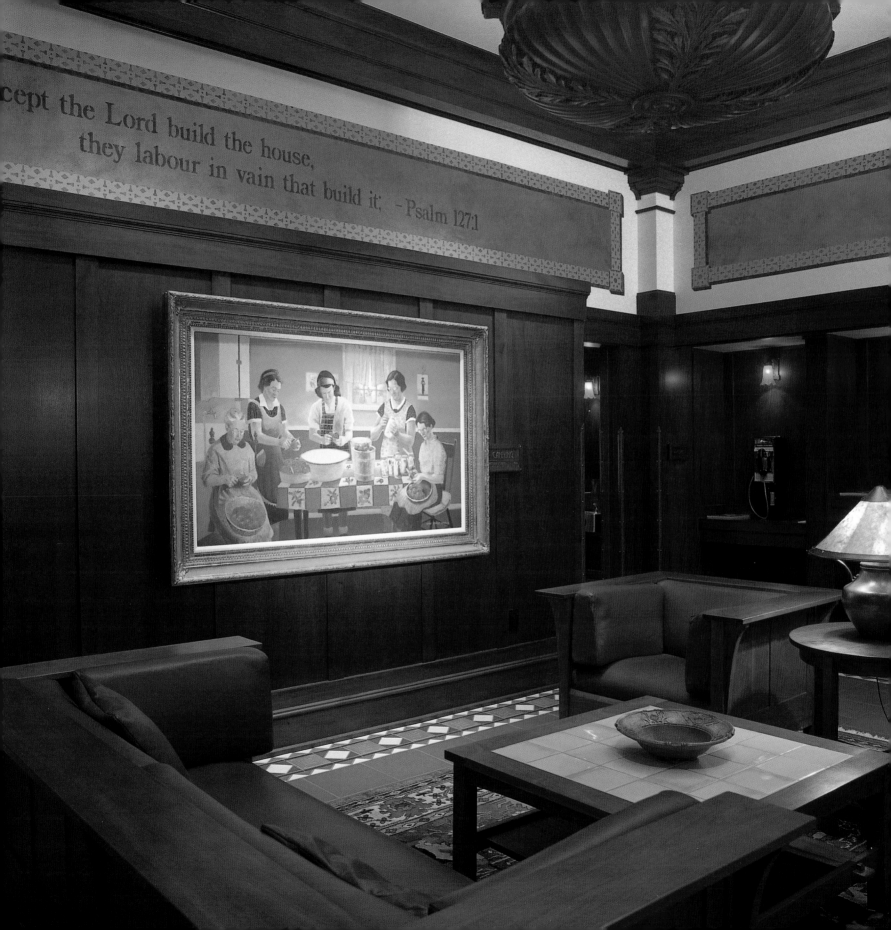

Art brings us closer to reality,
both that reality which is outside ourselves
and the reality inside us.
It helps us understand ourselves
better, as well as the world
in which we live.
Art is a window on reality.

— Roberta Green Ahmanson

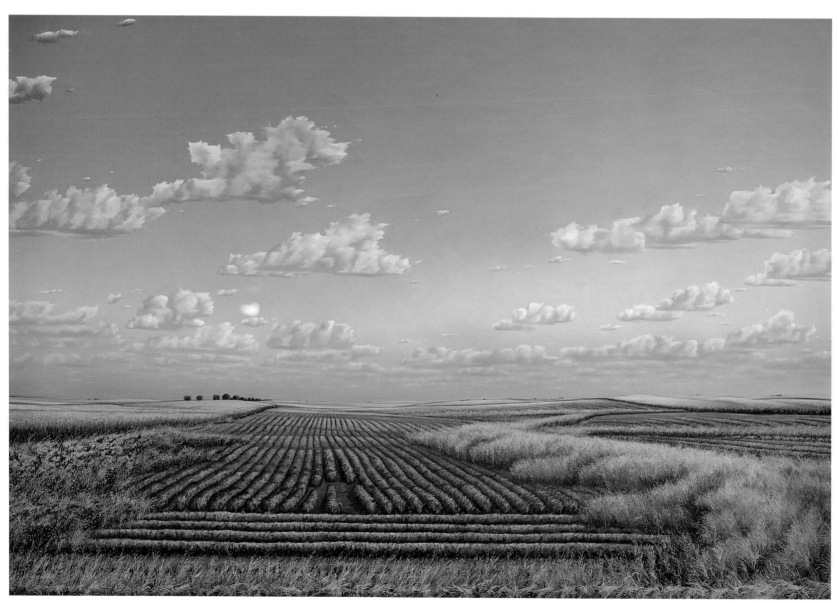

Ellen Wagener, *Landscape, Suite in Three Movements* (one of three images), 1997
Pastel on paper | 38.5 x 57.75 inches

About the Artists

All artists — whether working in words, sounds, or visual images — put "a frame around the moment, and what the frame does is enable us to see not just something about the moment, but the moment itself in all its ineffable ordinariness and particularity," writes Frederick Beuchner.

In the studios of the artists whose work can be found in the Hotel Pattee, we catch glimpses of those isolated moments, framed in wood or steel or gilt, or leaning unframed against an easel, still coming to life under the hand of the creator. We find ourselves surrounded by images in various stages of development that reflect myriad moments, each one suspended in time.

We first take note of shapes and shadings and subjects. If we are technically minded, we wonder about the media the artists have chosen, the processes they've gone through, perhaps whether they have relied on photographs or embarked on *plein air* expeditions. We contemplate the dimensions of a work and the stretch of the canvas and the size of the brush. We notice that some of the artists use traditional materials such as oils or pastels or acrylics, while others use wood or steel or colorful fabric or finely glazed clay.

Before long our thoughts are eclipsed by our senses. We respond to colors; we identify with images. We can almost smell the air; we nearly feel the morning chill or the heavy humidity of an impending afternoon thunderstorm.

We are engaged — we feel a surge of excitement at the sight of a cloud-strewn sky. We are calmed by the carefully ordered rows of a summer bean field. Something stirs a long-forgotten memory; we revisit a time of our lives that we can barely remember or a place that no longer exists. Sometimes our response is to a carefully represented scene; sometimes abstractions reach us intuitively, capturing our imaginations and our curiosity.

We begin to see the landscape through the artists' eyes. "Look," we hear ourselves saying, "there's an Ellen Wagener field." "That hillside looks like a Betty Lenz quilt." Or, simply, "Oh, look. Another John Preston."

And finally, we start to see the world in new ways through our own eyes — we became more aware of light and shadow, of the arrangement of clouds, hills, and fields, of the simple beauty of barns and animals and old, stately trees. We have been given a new perspective. We have begun to frame the world for ourselves.

As we listen to the artists, we learn that for the fortunate, art can be profitable. Even so, some of the Hotel Pattee artists eschew commercialism, instead drawing their motivation from a deep passion to perfect their technique. They sometimes paint the same scene again and again, experimenting with different light, different seasons, different points of view. For them, it is a great blessing when a piece sells. It is a valuable lesson even if it doesn't.

Some artists work on commissioned pieces with mixed emotions, grateful for the financial benefits but uneasy about the distraction from their own vision, their personal projects. Others have a bent, perhaps even a gift, for commercialism, and they are energized by their application of creativity and inspiration to clients' requests and to marketing and sales.

And why, we ask them, do artists do what they do in the first place? The answer is simple: They are artists because they have to be artists. They tell us that they cannot *not* create. Their art is not only what they do; it is a significant part of who they are. Not a few of them describe a common early schoolroom experience — the reprimand of a well-intentioned teacher for their incessant drawing on the backs of papers instead of the completion of class assignments on the front. Then, as now, they just couldn't help it.

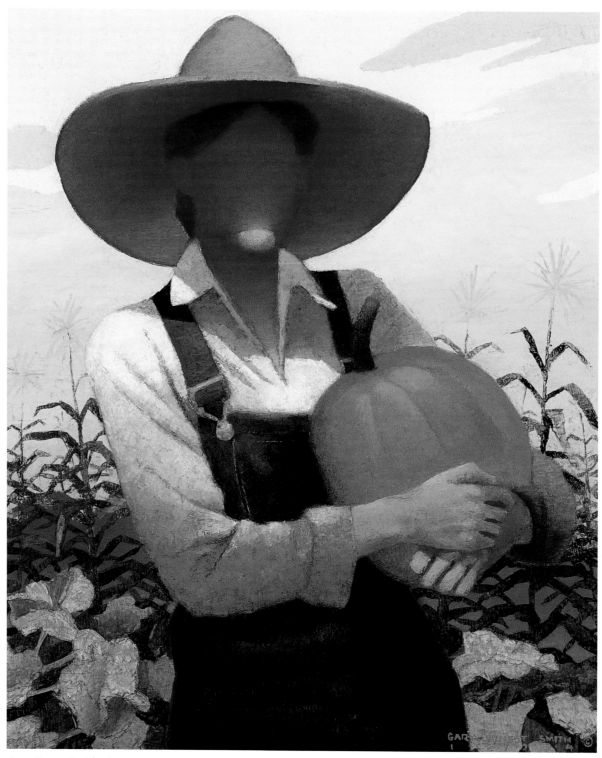

Gary Ernest Smith, *Autumn Harvest*, 1994
Oil on canvas | 36 x 30 inches

Some of the Pattee artists are often philosophical, exploring metaphor and uncovering hidden symbols in their work. Others are pragmatic, focusing on medium and skill, leaving the interpretation of their work to others. A handful of artists are communal, enjoying the ideas and experiences of other like-minded colleagues. But more than a few are solitary souls who work alone and keep their own counsel.

The men and women whose artworks can be found in the Hotel Pattee are deeply thankful for the paintings and sculptures that, in their eyes, they have simply received through some mysterious process and then passed on. At times they are surprised by what comes from their hands, finding unexpected beauty and character in their own creations, qualities that exceed their initial imaginings. They seem to be awed and humbled by what they create and by their vocation, cautiously describing themselves as diligent, disciplined, and somewhat lucky.

The artists acknowledge the spiritual aspect of art but describe it in different ways. One common theme is the mystery that underlies art's allusiveness. Many of them embody the statement "Art makes the invisible visible." They mention art's universality as it touches common chords in the minds and hearts of those who appreciate it. Several speak of the imprint of God's image on humankind, an imprint that places creativity within the nature of all people. As G. K. Chesterton wrote, "Every true artist does feel, consciously or unconsciously, that he is touching transcendental truths; that his images are shadows of things seen through the veil."

A walk through the Hotel Pattee's front door and around the common areas where many of the artists' finest works are displayed reveals their visions of overarching skies, adrift with clouds. Furrowed fields. Faces of family and friends. Weathered barns and rural schoolhouses. Creeks and woods, farms and fields, the prairie sea.

In the pages that follow, we enter through the hotel's front door and move into the reception area and the lobby, from the lobby into the restaurant, library, and public areas, and then up the stairs into hallways and guest rooms. As we make our way through the hotel, we hear from the artists about their works, and we view their art.

The scenes they depict may be carefully representational and precise. They may be impressions, perhaps only suggestions of a place or a character or a memory. Artist by artist, every view is different. But the captured light, the tones, the hues, the textures, the compositions allow us to experience Iowa, and beyond Iowa the Midwest region, and beyond that the greater world, as seen through the eyes of the artists of the Hotel Pattee. These women and men, without exception, cherish beauty, attempt to capture it, delight in framing it, and gratefully pass it on to us.

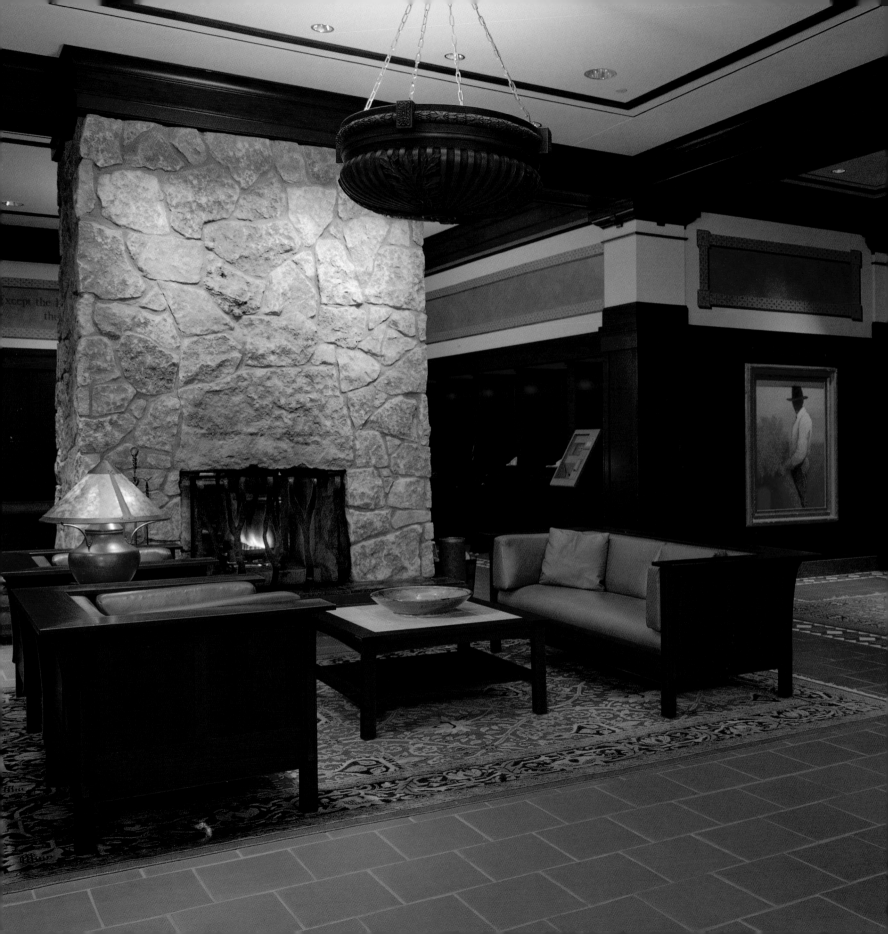

I knew that if the hotel deteriorated
any further than it had already,
it would be the last straw to downtown
Perry because it was such a big building.
If it ended up being demolished,
it would take the heart and soul
out of the town. I didn't want to see that
happen. So I thought, I can fix this up.
And that's how it all started.

— Roberta Green Ahmanson

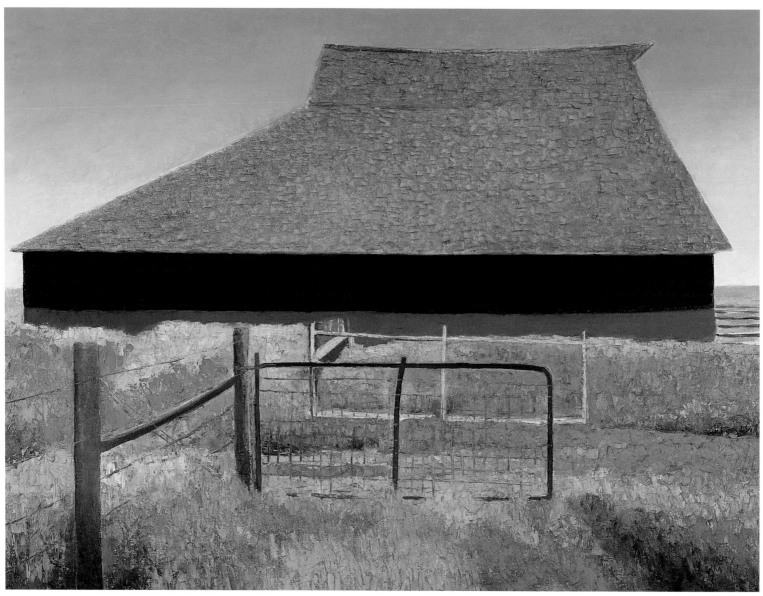

Gary Ernest Smith, *Iowa Barn*, 1999
Oil on canvas | 30 x 40 inches

The understated elegance of the Hotel Pattee's lobby invites the visitor in toward the crackling wood fire, into the ambiance of rich wood and subtle light, and into the collection of art carefully placed throughout the public areas. Probably the first to catch the eye is the work of Gary Ernest Smith. A respected painter, Smith's rural icons radiate the warmth of sun-baked soil, the broad stretch of limitless sky, the rough texture of harvested fields. And his paintings are often enlivened by images of those who live on the land.

A visit to Smith's studio, located in Highland, Utah, reveals his fascination with rural subjects. Vast paintings of winter fields fill the room, along with colorful, smaller portraits of family gardens, transitioning seasons, and other beloved scenes. But the field paintings dominate the studio.

"I like to find the beauty in real simple things," Smith says. "I never thought painting fields would have any significance at all. But since I started doing that, I have so many people coming to me and saying, 'I've never looked at fields the same way I'm looking at them now.'"

As to his figurative work, he explains that it is symbolic, with shadowed faces and simplicity replacing detail. Smith is often asked about paintings in which faces are left without specific features. "It universalizes the figures," he explains, "which represent not individuals so much as a collective group of people. You can read into the painting whatever you want to."

Smith speaks in similar terms about landscape. "Over the years the varied landscapes of America have continued to offer meaningful symbols to me … light and shadows play across landscape, creating abstract shapes and moods. Hay bales are placed in fields as if man and nature were working in design harmony. Interesting lines of planted or plowed furrows indicate both intriguing form and function.

"I find myself somewhere between traditional and contemporary art, and my work kind of reflects that. I want to show the positivism of life. Of course, sometimes negativity can be used in positive ways. But, above all else, I want my paintings to be positive."

One of Smith's paintings in the hotel lobby depicts a fiddler playing in an open field. It is called "Celebration of Life." Smith's intention was to celebrate the lives of those who work the land; music became the symbol. After the painting was completed, Smith found that he had depicted an actual event. "A man from Texas came in," he recalls, "and he looked at the painting and said, 'Well, how did you know about this? When I was a boy in Texas, we would go out and harvest the land and then we'd get it ready for the next year by playing music.' I had no idea about that when I envisioned the painting."

Surprising as that encounter may have been, it is very much in keeping with Smith's sensitivity to the elements of life and light and land. For him, art is nonverbal communication intended to touch the soul of the viewer. Concepts that cannot be communicated verbally can be expressed through symbols. Putting people back in touch with the land is important to Smith, and art is his medium.

"People who live in large cities have no idea what it takes to grow food. You go to the grocery store and you see produce neatly packaged, and you see the meat in the meat counter and have no concept of how it got there. Kids get a carton of milk and don't even know where that came from. These people are surrounded with concrete, steel, and glass. Many Americans have lost touch with what dirt is, when it really is the substance of life. That's what a lot of these large paintings are about — celebrating cycles of life and growth."

Smith also points out that people who live on the land are

Gary Ernest Smith

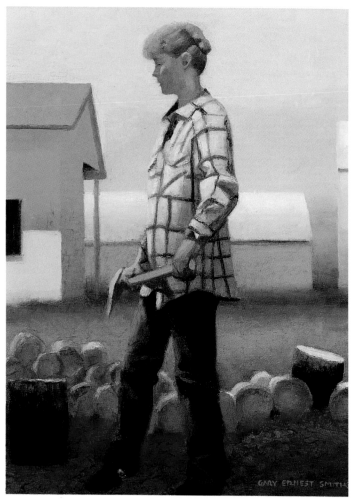

Gary Ernest Smith, *Wood Splitter*, 1994
Oil on canvas | 24 x 18 inches

closely attuned to the seasons. They are able to see, day after day, the gradual process of growth. They rely on sun and rain and weather patterns and, in his words, "go through agony just to harvest a crop." His field paintings capture their lives.

"I first got the idea of doing these large paintings, and I knew they had to be large because I wanted them to be kind of enveloping when you looked at them. To totally capture your attention of that vastness of space. I get a sense of well-being by being out in the field by myself, with kind of the wind blowing. For some people, the vastness is uncomfortable. But not for me.

"You can look at my field paintings as a big, broad expansion of space, with intricate design patterns and textures, and appreciate them on that level if you want to. But they are religious paintings in the sense that they are dealing with the substance of the earth itself. They are about where we come from and where we're going when this is all over."

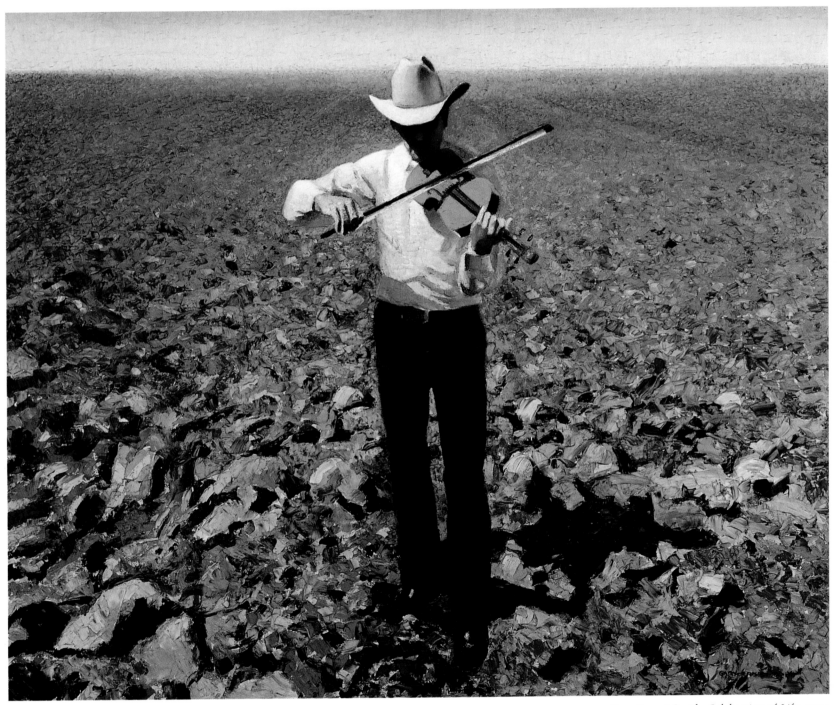

Gary Ernest Smith, *Celebration of Life*, 1995
Oil on canvas | 48 x 60 inches

Gary Ernest Smith

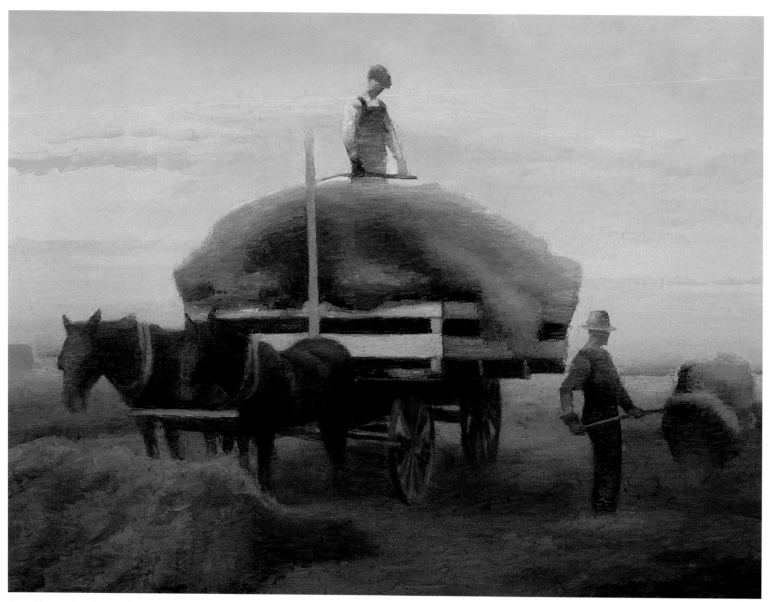

Gary Ernest Smith, *Loading Hay,* 1994
Oil on canvas | 30 x 40 inches

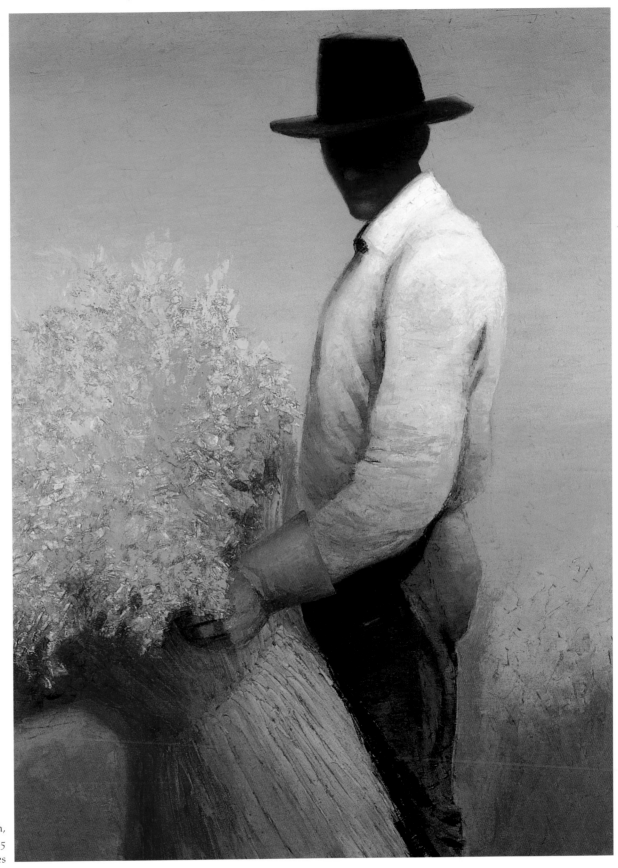

Gary Ernest Smith,
Figure with Wheat Bundle, 1995
Oil on canvas | 48 x 36 inches

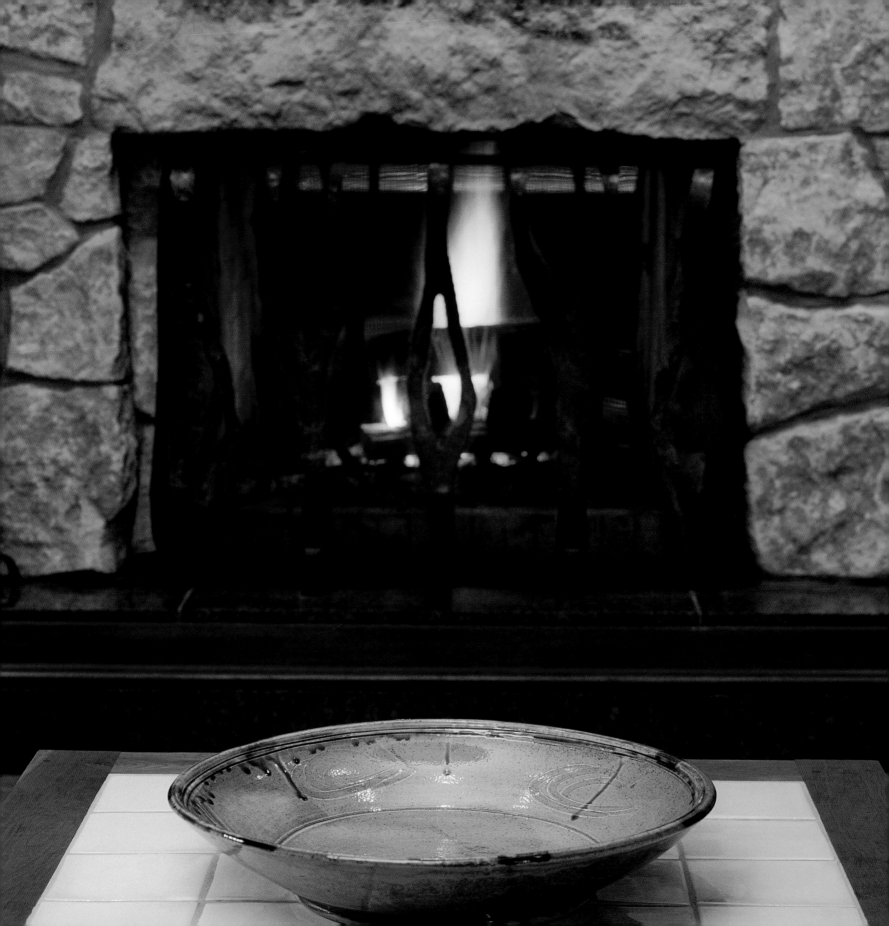

The hotel stands in a tradition that
for centuries invited weary travelers
to take their rest by a cozy fire
with good food and a warm bed nearby.
You'll find such fire dancing
in the great stone fireplace in our lobby,
lighting the copper-hooded hearth
in the library, or sparkling in one of
the tiled fireplaces in four of our suites.

— Roberta Green Ahmanson

Eric Peterson

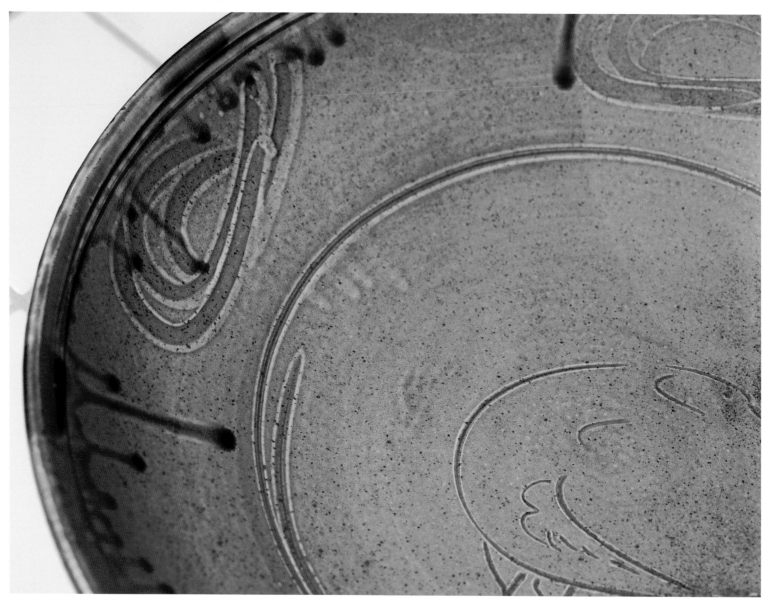

Eric Peterson, *Untitled,* 2000
Ash-glazed stoneware | 20.5 inches diameter

In the center of the table in front of the lobby fireplace stands a large ceramic bowl. A darker glaze drips from its edges. A bird stands proudly in its center. The name of the potter, Eric Peterson, is not immediately evident, but the quality of the piece speaks to its creator's skill. Peterson is not troubled by anonymity. He is much more interested in the community of potters — centuries old and worldwide — in which he finds himself.

"I don't know why I love pottery. As a teenager, I remember seeing a film of a guy making a pot and it just captured my imagination. I think everybody has those areas in their life. It's hard for some people to understand. How can you like a pot? Yet it has a beauty that does not have to have my name on it. It's not an issue of name or notoriety."

Perry, Iowa, has been Peterson's home for five generations. His great-great-grandfather, Lewis Peterson, immigrated from Sweden to Perry and worked on the railroad; his great-grandfather Frederick and grandfather Robert were also railroaders. Although Eric and his father, Fred, broke the railroad tradition, both continue to live and work in Perry.

"The bowl that's in the Hotel Pattee was done out here in the barn," Peterson explains during a tour of his pottery workspace, which includes a hand-built kiln, potter's wheels, and a haphazard array of bowls, cups, vases, and other vessels in various stages of development. "If you look, there is a bird inside it and some swirl marks. I made those with my fingers. . . ."

He goes on to describe the final process. "It's glazed with an ash glaze. You'll notice that there are drips down the sides. The glaze tends to move when it heats up in the kiln, and that's why it sort of rivulets or drips toward the center."

Peterson's work reflects a tradition of Iowan pottery that goes back for generations. During the 1800s, local pottery shops made functional ware that wasn't as attractive as it was useful. Most Iowa clay lies deep in the ground, and many times in the past the clay would be dug up during the coal-mining process, the kiln actually fired with the coal. But the clay in Iowa is unpredictable, and, in order to make pieces of consistent quality, potters find it more practical to import clay from other areas.

"The glaze on the bowl at the hotel is from Iowa," Peterson says, "but not the clay. The majority of the glaze — the green glaze that covers most of it — is made from 73 percent material from Iowa. And the rim glaze that runs and gives that color is an all-Iowa glaze."

A careful student of his craft, Eric Peterson has done extensive research into the history and tradition of pottery and has integrated various techniques and combinations of clay into his own work. With a serious, spiritual view of life, Peterson has reflected upon biblical references to God as the potter and humankind as the clay. Perhaps these lessons are particularly meaningful to him when the clay is less than cooperative. Having lived among strong-willed, down-to-earth Iowans for a lifetime, he seems unsurprised by the fact that even the Iowa clay has a will of its own.

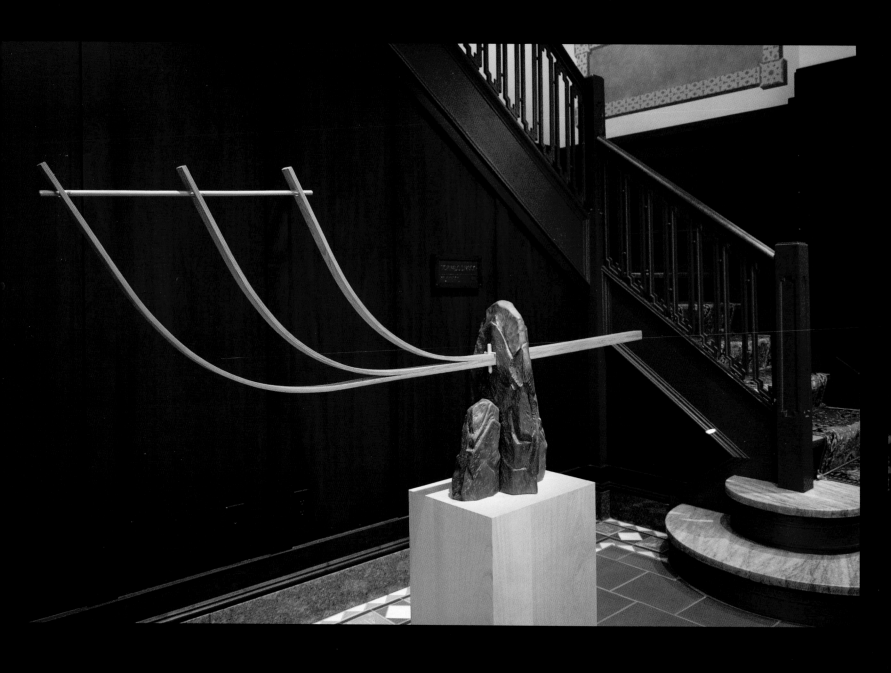

Mac Hornecker

*That's what I like about art — there isn't
an answer there.
It just raises more questions.*
— Mac Hornecker

Further into the Hotel Pattee lobby stand two abstract sculptures by Mac Hornecker. Like the sculptor who made them, they are strong and spare in their composition, subtle in their irony.

Hornecker, who grew up in rural Missouri, has been a professor of art at Buena Vista University in Storm Lake, Iowa, for thirty years. In his enormous studio, set on a windswept hill, he smiles wryly as he tells the story of his career. "Art was kind of an unusual pursuit in Missouri. Everyone expects you to get a real job, you know. And I did, to support my art. My dad was in construction and so was his brother, and they just took us kids to work with them. So, from the time I was six or seven, I was learning the construction trade.

"When I first went to art school in Kansas City, I was going to go into graphic design, and then I realized I was big and physical and that's what sculptors were. I identified with the sculptors in other ways, too, and that's where I ended up. It was more exciting to me and more interesting than any other medium. I started out as a woodcarver. And, although I earned a little extra money doing drawings of people's pets in the early years, when it came to sculpture, I always did abstract work."

Mac Hornecker is inspired by the elements of the earth, by the interaction of rocks and wind, of water and wood. "Growing up on the farm, we looked at the landscape at our feet. And a lot of these pieces sitting around the studio today have to do with glaciers that made the landscape. They slid across the ground cutting through rock. In nature, you see where rivers cut through solid rock. The close, personal aspects of landscape affect me a lot more than the best of sunsets."

Hornecker points out that although a sunset may be beau-

tiful, he is all too aware than he cannot capture its beauty. Instead, he is drawn to the way elements, shapes, and forms work together. "I don't see something and say, 'I'm going to make a piece of art out of this.' My ideas are more eclectic, building up over years and years as I discover new things about the landscape. I like to talk to geologists and other scientists who study the earth. That's where I get my ideas."

One of the two sculptures in the hotel lobby is called "Tornado Struck." It's all wood, even the boulders. As a college student, one of Hornecker's daughters majored in meteorology and was occasionally involved in tracking tornadoes. This focused the artist's attention on the force and violence of storms that are legendary in the Midwest. One oft-told Iowa tale, which has many versions and variations, describes a feather driven through a tree trunk by tornado-force winds.

"'Tornado Struck' refers to a similar story," Hornecker explains. "A tornado-driven piece of wood hit the rocks. It split and came up into a sort of a pitchfork shape. That has to do with the legend of a stick being driven through a rock."

The story behind the rocks that Hornecker fashioned for the sculpture also takes an unexpected turn. Earlier in his career, Mac Hornecker made the rocks in his sculptures out of concrete. Later, he turned to steel, which he welded into rock shapes. In "Tornado Struck," however, the rocks are carved out of wood.

Hornecker likes the ambiguity of the medium. "People don't usually realize that the rocks are wood. A wooden rock. I was recently at the Grotto in West Bend. There is a lot of petrified wood there. It's real interesting to reflect on the difference between the rock and the wood. The wood's still there, but now you recognize it as rock."

As to what he calls the "phony rocks" of his own design, Hornecker says, "Art is sort of a phony. I got this idea from

Mac Hornecker, *Tornado Struck*, 1995
Wood | 24 x 85 inches

Mac Hornecker

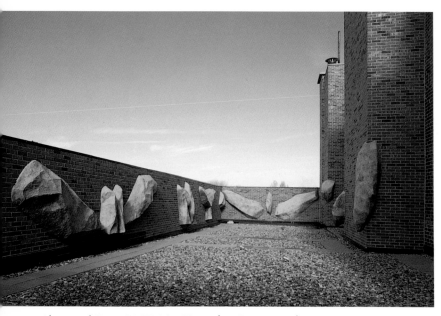

Above and Pages 36-37: Mac Hornecker, *Prairie Markers*, 1997
Steel | sizes vary

working with my students for years when they were doing their life-model drawings. They were talking about their drawing as 'her.' 'It's not a her,' I told them. 'It's a drawing, not a person.' In the same way, people say, 'Well, I like realistic art.' When you think about it, there's just no such thing as realistic art. I guess that's sort of a humorous aside, a sort of tongue-in-cheek idea that I like to play with."

When he created "Up the Creek," Hornecker had been working with circle shapes. He started out with a simple circle. Then the rock form was pinched and the circle fanned out into the oar shape. "And so," Hornecker concludes, "I just thought, 'Up the creek without the paddle;' you've got a paddle, but it's useless. And that sounds like a lot of the stuff that I own."

On the walls of the courtyard, outside the hotel's second-floor windows, Hornecker created an environment he named "Prairie Markers."

He recalls how it started. "When the land was surveyed in southern Missouri, the surveyors would take a rock off the landscape and stand it on its end as a landmark. As a small kid, I saw one of those and said, 'What's that rock?' Young as I was, I realized it wasn't natural. It had been placed there. As an adult, I always wanted to do a tribute to those rocks. At the Hotel Pattee, I was asked to work on the roof wall. It was the first relief I'd ever done. And so I started thinking about that childhood memory: 'These rocks are out of place.'

"Because of the way the rocks are positioned on the walls, you can't see the whole thing from one spot. You would have to work your way into all the rooms to see the whole thing and you'd have to build it in your mind. So, it's like a landscape. You don't see the whole landscape when you walk up to it, but you remember certain elements by the end of the day. So, that's what that piece is all about. It was a tribute to those landmark rocks."

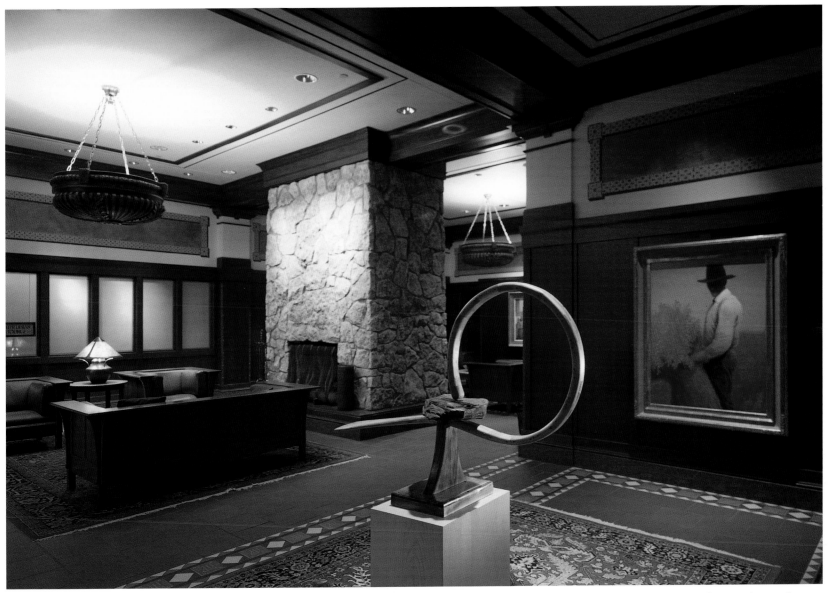

Mac Hornecker, *Up the Creek*, 1996
Wood | 37 inches high

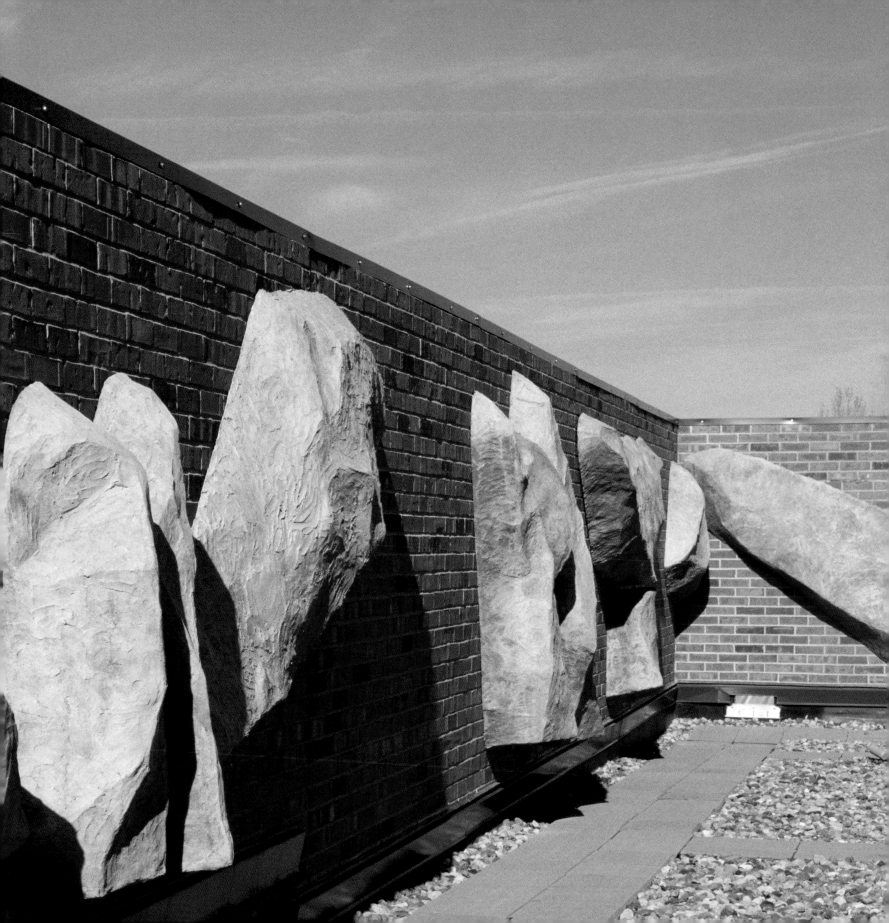

I thought, Well, okay, we're going to do this.
We're going to restore the exterior
to what it was. We're going to put the flagpole
back up on top. We're going to clean up the
name Pattee, which is carved in stone
on the top of the hotel. We're going to put
the canopy back on. And that's what we did.

— Roberta Green Ahmanson

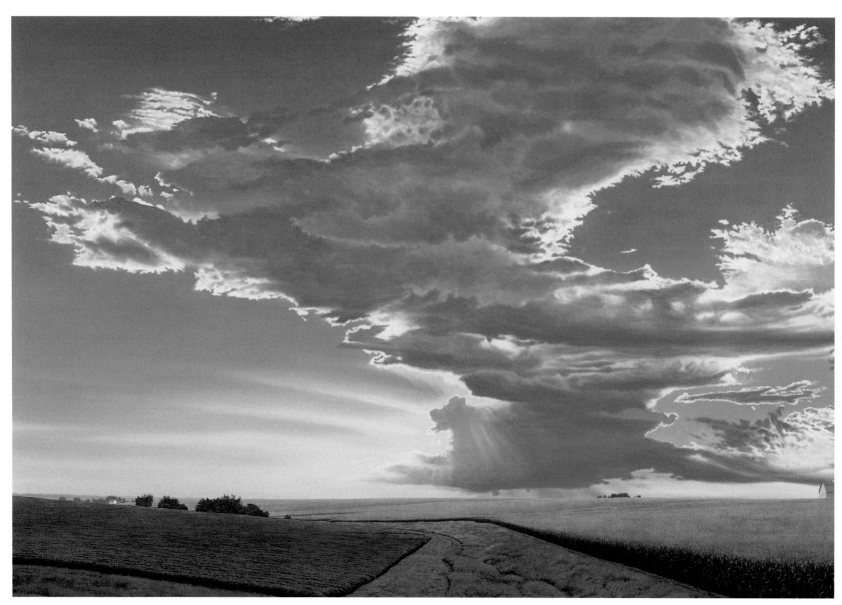

Steven Kozar, *Outside the Amana Colonies*, 1998
Watercolor on paper | 34 x 51 inches

Steven Kozar's paintings in the Hotel Pattee lobby and public spaces often cause visitors to take a second and even a third look, so great is his skill, so realistic his technique. "Is that a photograph?" observers sometimes whisper to one another. The answer is no. What they are seeing is the finely detailed work of a careful painter. Kozar's precise depictions of scenes in and around Perry and the Hotel Pattee capture the area's history and way of life.

Kozar describes the beginnings of his photo-realistic technique. "When I first started out, we lived in Chicago and I was doing paintings for class. I didn't have a camera yet. I borrowed somebody's camera and borrowed somebody's car and took a bunch of photos trying to get something to paint. I wanted to paint the rural countryside, the sky and the land.

"I used prints at first, but after a year or two I learned that slides were more accurate. Then shortly afterward, I began painting professionally. Up until then, I had been sort of eye-balling the slides with a little viewer and drawing freehand. I soon realized that if I kept doing that, I was going to go broke. It was taking me way too long."

Kozar had read about other artists, whose work he respected, who projected slides, then sketched out their drawings by tracing directly from the slides. The technique speeded up the process for him and has been his method for most of his work since. Although he is presently retooling and expanding his portfolio to include works of oil on canvas, the Kozar art displayed in the Hotel Pattee is watercolor.

"I very specifically composed the work at the hotel with the camera," he explains. "For instance, the scene of the library. I was there for most of the day and I took a lot of slides. Then, just as I was about to drive home, I saw these long shadows forming. I was so excited that I stood in the middle of the road and the cars had to go around me!"

Roberta Ahmanson was collecting Steve Kozar's art before she and her husband, Howard, purchased the Hotel Pattee. Then, in the early 1990s, Mrs. Ahmanson commissioned him to paint several local scenes specifically for the hotel. Kozar recalls his response to the assignment. "I used to be such a purist. Let me paint what I want to paint! And don't tell me what to do. Don't hinder me in any way. But as time went by, I realized that there's something to be said about taking somebody else's parameters and working within them. So I took my camera, walked around Perry, and recorded the scenes that Roberta wanted me to paint. I composed the paintings through the viewfinder of my camera."

Kozar made six or eight preliminary drawings. "They were a little bit more detailed than what I normally would do for myself. You could see the azaleas and you could see the detail of what everything would look like. I sent her all these sketches, and I gave her an idea of what they would cost and what the different sizes would be. She sent me back a very brief note that said, 'I like all of them. They made me cry. Do them all.'"

Close inspection of Kozar's paintings reveals painstaking detail and a commitment to perfection. It was, of course, a great benefit for him to have commissioned work for an extensive period of time. But the commercial aspects of art have never changed Kozar's view of his work, art's place in his life, and his philosophy about its impact upon the world at large.

"Beauty is a precious gift from a loving and tender God," he says. "Visual beauty surrounds us on a daily basis, but it is revealed by the careful hand of the artist. Music is perhaps the best way to be ushered into His presence, but like words, it is

Steven Kozar

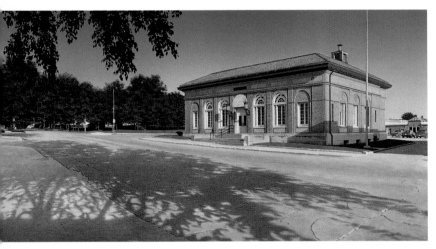

Steven Kozar, *Postal Building*, 1999
Watercolor on paper | 12 x 23.5 inches

not the only way, either. It is through our eyes that we can best receive God's gift of beauty. As the Bible tells us, 'For since the creation of the world, God's invisible qualities, His eternal power and divine nature have been clearly seen, having been understood from what they've been made, so that men are without excuse.'"

Kozar also believes that humankind's ability to create is the result of our being made in the image of God. He explains that he sees paintings in his imagination every day, twenty-four hours a day. Wherever he looks, he is continuously visualizing how something might look as a painting. He is forever framing the world in his mind.

"When people see a painting," Kozar smiles, "they are always thinking, 'Wow, look at the detail! Look at what he did with his hand. Look at those little brush strokes.' But what I'm really doing is taking a three-dimensional, real scene and trying to translate it onto a piece of paper or a piece of canvas."

As Steven Kozar paints, particularly as he seeks to capture the landscapes that he so enjoys, he hopes to communicate to his viewer the magnificence of God's creation. Although his message is nonverbal, he is always attempting to reveal the nature of a loving God who surrounds humankind with a wealth of natural beauty.

"I'm not going to think that people are going to come to a very particular belief because they looked at my paintings. That's not the purpose. That's the purpose of the sermon, that's the purpose of the speaker, that's the purpose of a more direct communication. But artwork acts on a more subconscious level. It reinforces the idea that life is precious, that life is a gift, that beauty points us to God. Beauty is a reminder."

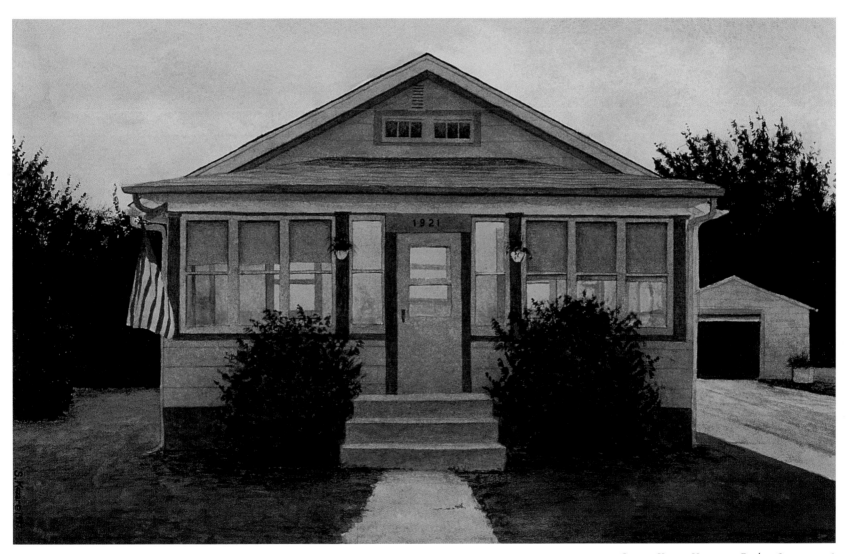

Steven Kozar, *House on Evelyn Street*, 1996
Watercolor on paper | 6.25 x 10.25 inches

Steven Kozar

Steven Kozar, *Park in Perry*, 1994
Watercolor on paper | 18 x 27 inches

Right: Steven Kozar, *Perry High School* (detail), 1996
Watercolor on paper | 10 x 24 inches

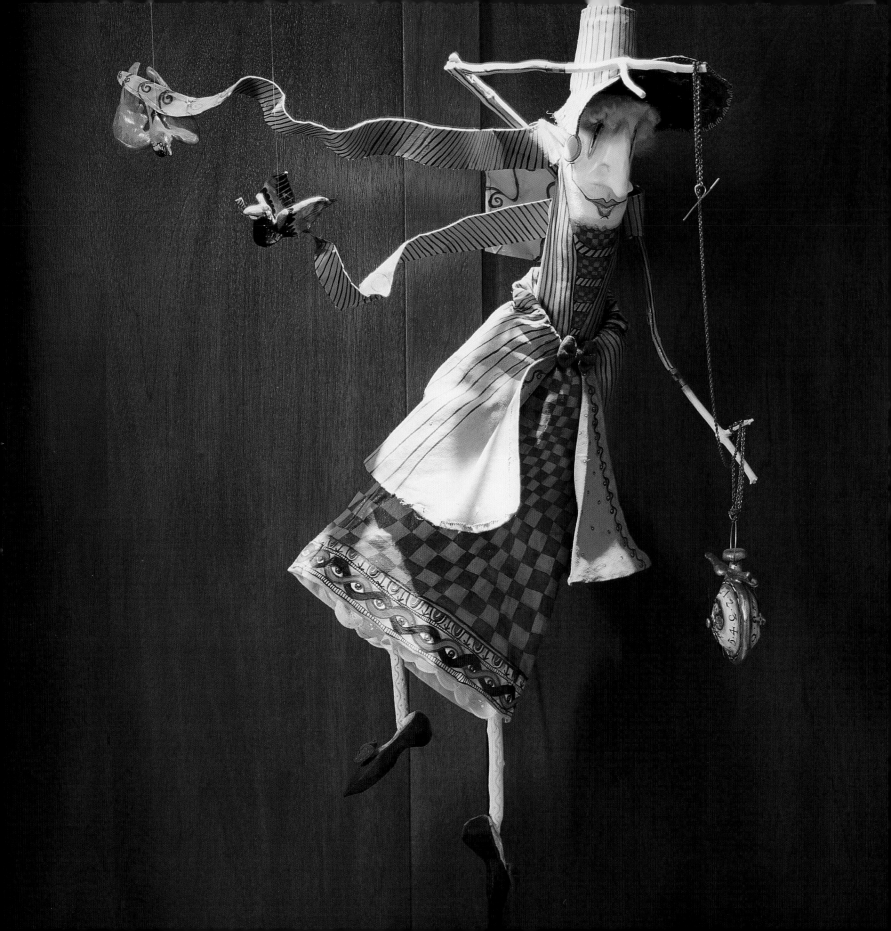

In Christianity and Judaism,
we believe that we were created
in the image of God — the *imago dei*.
That's who we are, so we can't not create.
It's not possible. We either create well
or we create badly. But we do create.

— Roberta Green Ahmanson

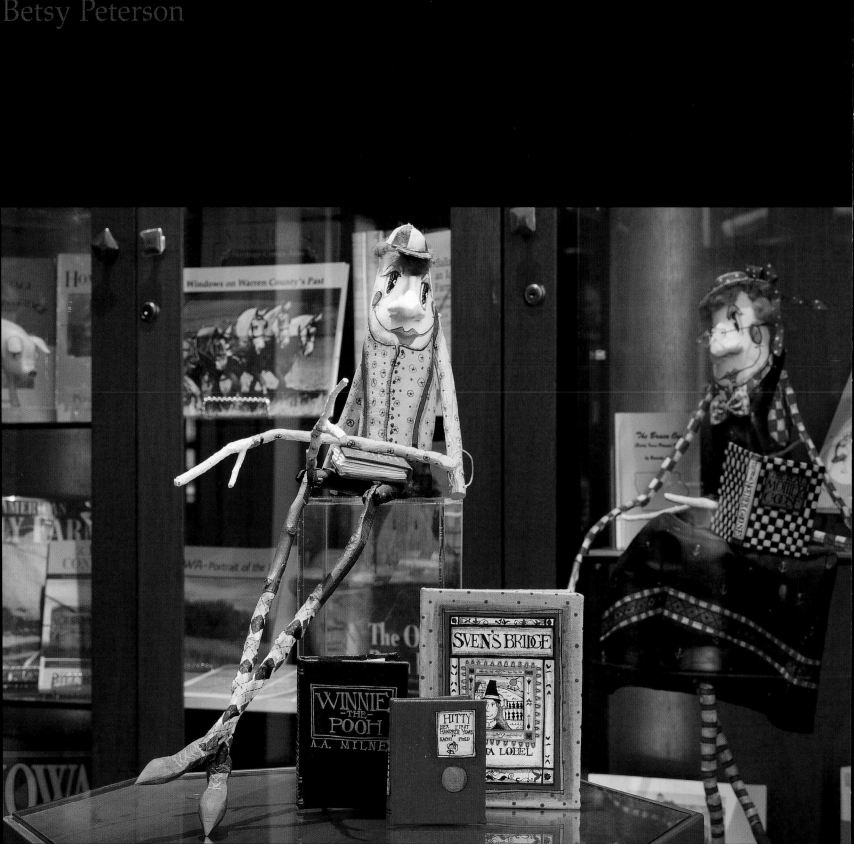

One look at Betsy Peterson's delightful creations and the phrase "folk art" is redefined. She calls them Humpty Dumpties, but they are far more than characters from a nursery rhyme. Fashioned of fabric and found wood, some are doctors, some are farmers, some are gardeners. There are railroad workers and moms and dads, but each one represents an aspect of the Iowa community, while bearing the imprint of Peterson's irrepressible vision.

Sitting with her two sons in the friendly clutter of their art-filled farmhouse, Peterson laughs as she describes the process of locating just the right pieces and putting them together. "When the boys pick up sticks before they mow the grass, they've learned by now to look for ones with fingers and thumbs."

Like the home she and her husband, Eric, have created for their boys, Peterson grew up in a very creative environment. One of five siblings, she describes a family in which her mother enabled her children to enjoy creating, to think creatively, and to solve problems creatively. "Mom is an artist also, who creates figures out of driftwood. The idea is similar to mine, but the style is different."

Peterson goes on to describe the characters that are in the Hotel Pattee's Willis Library. "It was a fun creative process to decide what to put on all the shelves and make them unified. It's kind of a family. A mother is reading *Mother Goose* to her child, and several of the miniature books that I made to go with them were books connected to my childhood — books my mom read to me and books that I've read to my kids. I really dig deep into those personal, intimate things that have shaped my life, and I use them in my artwork."

Betsy Peterson, *Mother and Child Reading,* 1997
Mixed media | 19 inches high and 31 inches high

When Peterson was five years old, her family moved to Iowa from New York State, and she has since then rooted herself in Midwest soil. "New England is full of friendly people, but I enjoy Iowa. I'm glad to be in the fields and look out the back of our barn at the soybean fields, and I love seeing the different color changes and the changing seasons."

The creativity that drives Betsy Peterson has filled her house, her barn, and her gift shop with whimsical art pieces. Color, shape, humorous phrases, and flights of fancy are characteristic of her work. But her inspiration bubbles up from deep within.

"I believe God created man in His image, and because He is such a creator, we can't help but have a creative spirit in us. If I could teach and nurture that creative spirit that He has put in each individual, what a joy it would be. What a treasure to continue the process that He began at creation. It is important for people to be taught, to be encouraged, to find hope, to be inspired toward freedom of expression."

She points to a painting above her mantel, a female character from which three-dimensional wings have sprouted and carried her aloft. Because of her faith, Betsy Peterson explains, "I have complete freedom in my life to fly, and take off and go, and use color in imaginative ways, or sticks in creative ways. This 'Freedom Picture' shows that I am free, that I have the freedom to use color, to use sticks, to put purple and orange together. I never even believed that purple and orange could go together. But there it is."

Betsy and Eric Peterson home-school their sons and are working together to raise them in a creative environment "where they learn to think outside the box and experience the freedom to try new things — good new things. God has given me a delight in children, and a delight in childlike faith. There are no limits or boundaries in that."

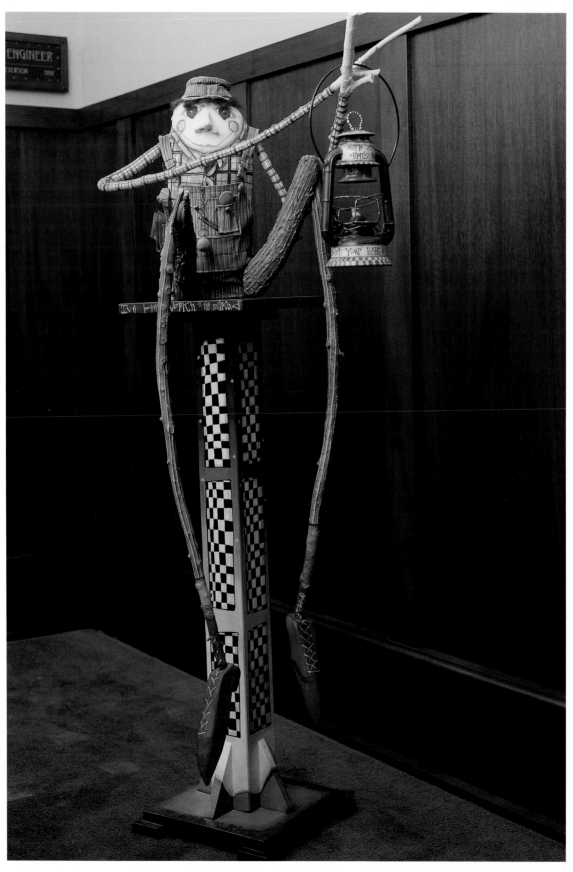

Left: Betsy Peterson, *Railroad Engineer*, 1997
Mixed media | 53.5 inches high

Right: Betsy Peterson, *Biker with Dog*, 1997
Mixed media | 16 inches high

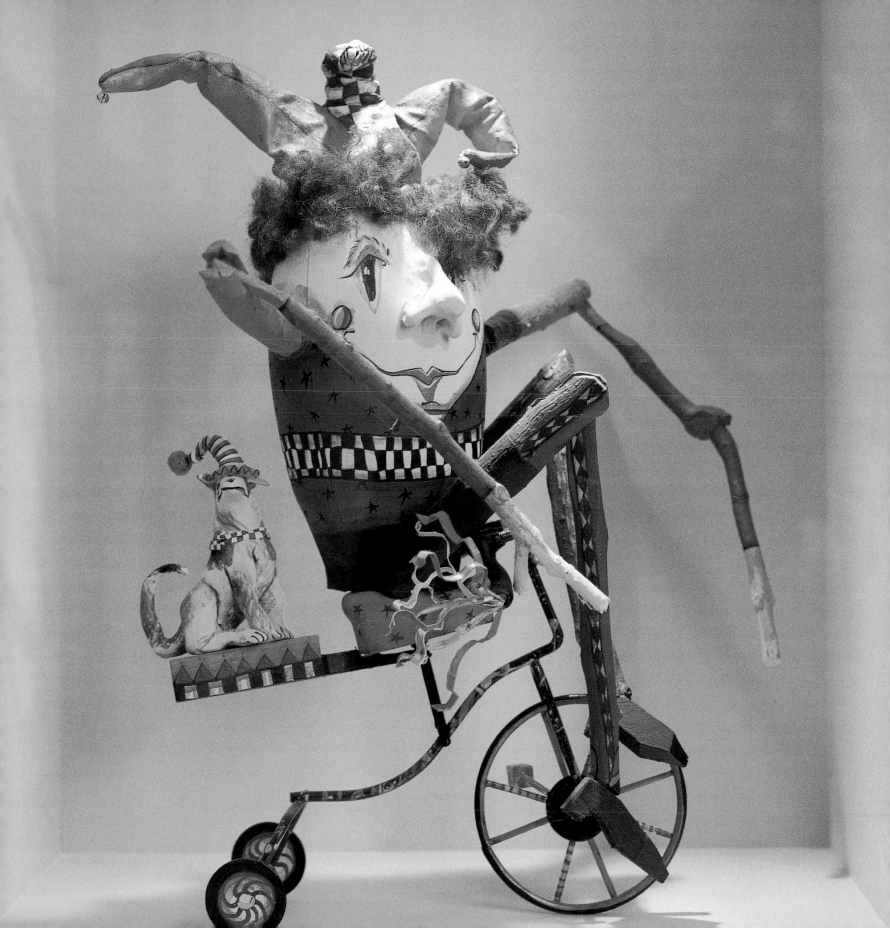

David Kreitzer

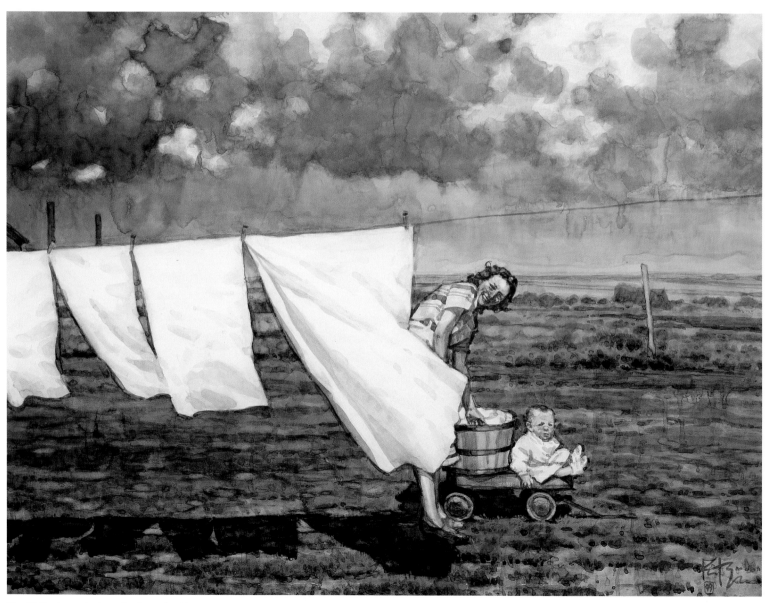

David Kreitzer, *Indianola: Laundry Day (1938)*, 1999
Watercolor on paper | 29.5 x 38.5 inches

*When you're born in the plains
and grow up in the plains, all you can see
are horizons. You're used to the long view.
You're not afraid to look ahead.*

— David Kreitzer

Some of the paintings guests at the Hotel Pattee say they love most are David Kreitzer's portraits of prairie life. Apple-cheeked farm children. Aproned aunts and bespectacled grandmothers preparing food. Farmers in overalls and worshippers gathered outside a church. The paintings capture a way of life that is rapidly disappearing from America's heartland. Innocent and evocative, Kreitzer's paintings suspend in time mid-twentieth-century midwestern life.

The story behind the paintings is the unplanned collaboration of father and son in an interdependent process. David Kreitzer's father was a minister whose hobby was photography. Over the decades of his ministry, he took innumerable photographs of the families in his Nebraska parish. Years later, his son David, by then a professional artist, began to use the photographs as basic compositions for a series of paintings.

In his studio near San Luis Obispo, California, David Kreitzer thumbs through sketchbooks while he describes his father. "I was born to an idealist. His father beat him because he read. 'Farmers don't need to read,' he was told, so he'd sneak books into his bedroom and read by candlelight. We're talking 1912. Finally, he found a man, a Lutheran minister, who took him under his wing and encouraged him. And that's why he became a minister himself.

"My father's first love was books, and photography was the other thing. He never got really good at it, but he was fascinated by it. He had an uninstructed eye, but that's what is so charming about what he did. He had a way of taking pictures that other people wouldn't have thought to take, like the cars outside of the church. Most people would say, Why? But, I'm grateful that he did it, because many of those country churches don't exist anymore. Neither do the cars."

As he leafs through the sketches, Kreitzer recalls his own early years, when he wanted to get away from the Midwest and experience the greater world. "I used to think, Why couldn't I have been born in New York, in a place where I could have had a head start? But I believe now it was all perfect. I had to be born where I was born, to the father I was born to. I was so fortunate. Often, artists don't come from artists' families. Kids by nature want to do something different. They don't want to compete with their parents; they want to find their own way. But, how lucky I was, having all my father's stuff."

David Kreitzer's artistic gift bridges the gap between fine art and illustration. In fact, he laughs at those who draw a distinction between the two. He has produced sweeping landscapes, promotional paintings for operas, and mystical pieces that reflect aspects of his inner life. "I believe that the act of painting is a form of active meditation," he says. "The artist achieves a certain level of meditation in order to paint. Then, looking at a painting, the viewer approaches the same level of meditation as the artist's."

Kreitzer's sketchbook contains dozens and dozens of images of his family's life on the plains in the 1940s. He grows animated as he thumbs through the sketches. "There is my uncle with his prize calf. And my brother's baseball team program — everybody's wearing overalls. That's the house where my mother grew up. My mother learning how to make soap from her aunt. This is a pastors' conference — Roberta has this at the hotel. Here's my father at his first church. It's another world. It's all gone."

The sketches, and the paintings that came from them and hang in the Hotel Pattee, prod the memories of people who know the way life once was in places like Perry, Iowa. They realize what has been lost, how ingenuous and nonmaterial their family life used to be. "We've all been kids," Kreitzer

David Kreitzer

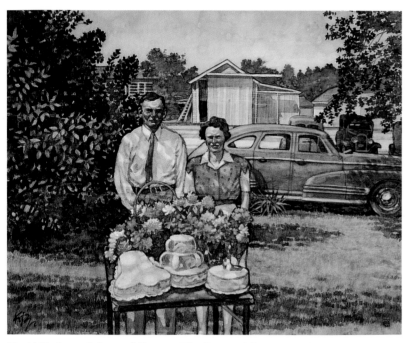

David Kreitzer, *Cakes and Flowers (The Farmers' Anniversary)*, 1997
Watercolor on paper | 28.25 x 36.5 inches

points out. "We've all been to our grandma's houses. We've all lined up somewhere in front of a house or a church to have our picture taken."

Whether recapturing scenes of midwestern life, first seen through his father's eyes, or depicting other views and other locales that stir something within him, Kreitzer never really knows what will emerge from the canvas that is stretched out before him. "I don't see things in my mind clearly. I can't close my eyes and see a scene. I can feel it and I can sense it. But if I want to see it, I have to paint it. After it is painted, I see it for the first time. There is a sort of mysticism you breathe into a painting as you make it, and it comes back to me as I view it."

Describing the creative process, he sees human art as a rough means of reflecting the Creator's genius. "We take these crude materials, organize them, and it's called a painting or a sculpture. So this is sort of our kindergarten in God's school. First lesson: how to take an idea and make it real, real enough that somebody else can relate to it."

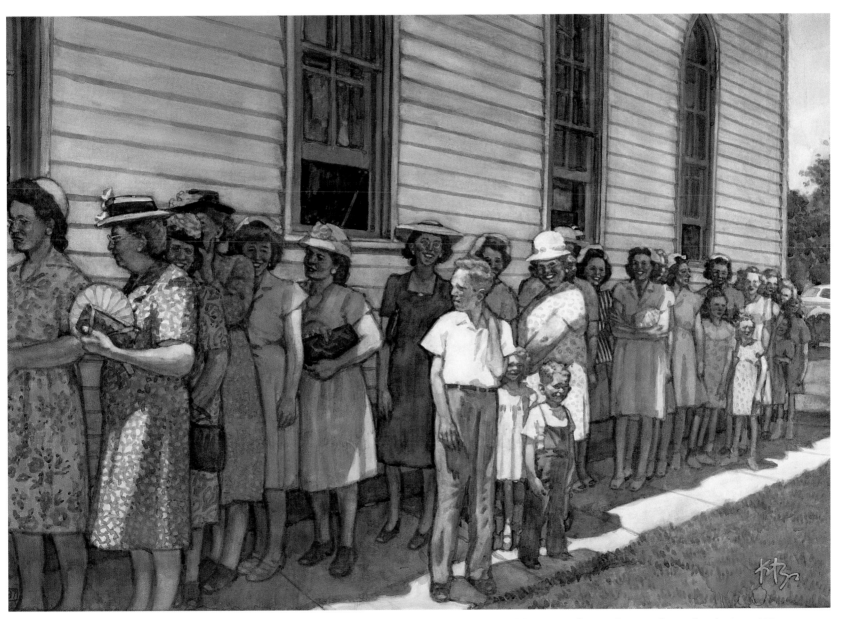

David Kreitzer, *Women and Children First: The Lunch Line, Christ Church, Cairo, NE 1946*, 1997
Watercolor on paper | 27 x 39 inches

David Kreitzer

David Kreitzer, *Uncle Milt*, 1999
Watercolor on paper | 28 x 21.5 inches

Right: David Kreitzer, *Chautauqua Tents (Hillsborough)* (detail), 1998
Watercolor on paper | 27 x 40 inches

Doug Shelton

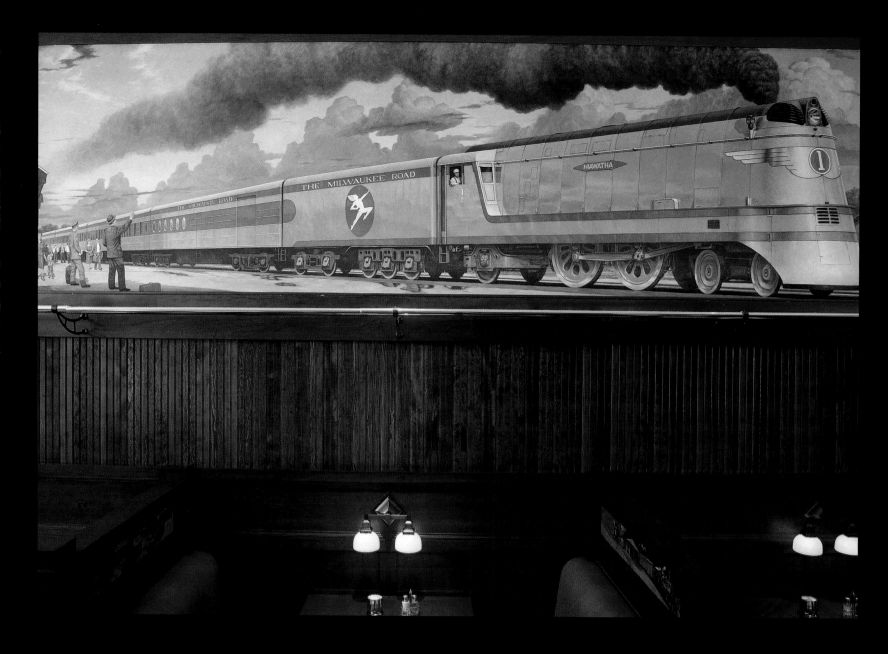

Doug Shelton, a native of Des Moines, learned many lessons in Iowa. He learned not only in the private art lessons he began during high school, but in observing the greater picture of life — the seasons and the natural beauty that so inspire his work. Like most artists, he has come to see that the process of creativity must be nurtured. It is a process that has something in common with the process of farming — planting, growing, harvesting.

"I think about the farmers and the way they work the land. They have to leave it fallow for a year every now and then. That fallow time regenerates the soil. I like to think about that year when everything kind of returns back to a state of normal."

Although his adopted home in the Arizona desert offers a far different view of nature from the Iowa fields, the landscape and lifestyle of Iowa have molded Shelton's work as well as his point of view. It is not surprising, then, that he was able to create the large murals that depict life in Perry, Iowa, during its heyday as a railroad town for David's Milwaukee Diner.

"One of the murals in the dining room is of the Hiawatha, which in its day was the fastest train around," Shelton reflects. "The locomotive was very streamlined, very art deco. And across the restaurant is another mural, called 'Midwest Rails,' of an old coal burner. It includes the station and the people in their period dress. The train research was fun for me to do. I borrowed books and I bought books. There is a train museum in Boulder where I went and found out the particulars about that 1913 engine. There was a lot to learn — I had no idea."

There is another Shelton mural at Iowa State University. "It was created in the same tradition as the renowned Grant Wood murals and painted in celebration of the university's 140th anniversary."

Much of Shelton's work, however, is of quite a different nature from his murals. Although the style is sometimes called surrealism, Shelton describes it as "magical realism." He explains that it is inspired by "lots of things. The visual world. The trees and clouds, things you can see. But science also inspires me. Quantum physics. If you look closely at a piece of plastic, it's made of a bunch of molecules, but if you take a molecule and enlarge it to the size of a basketball, there's nothing there. I've done a lot of paintings where you just unfold it — life is like a curtain — and there's a whole other world behind it."

Doug Shelton often returns to specific themes in his work. A concerned environmentalist, one of his favorite subjects is nature versus civilization. But although there is a deep current of philosophical reflection running beneath the surface of his art, when asked what he hopes art brings to the world, he walks to a large window and gestures toward the expanse of Tucson's rolling hills, punctuated by stately saguaros. "We have to remember to see what's around us. For example, when I first came to this house, I was amazed by the views — they were unbelievable. But after a few months, I wasn't seeing the views anymore. I think a really good piece of artwork opens your eyes to the same old thing, so you can appreciate it again."

Left: Doug Shelton, *Hiawatha*
(detail from mural in David's Milwaukee Diner in the Hotel Pattee), 1997
Oil on canvas | 23 x 60 inches

Doug Shelton

Doug Shelton, *Spirit of Perry* (detail), 1997
Oil on canvas, mounted | 6 x 28 feet

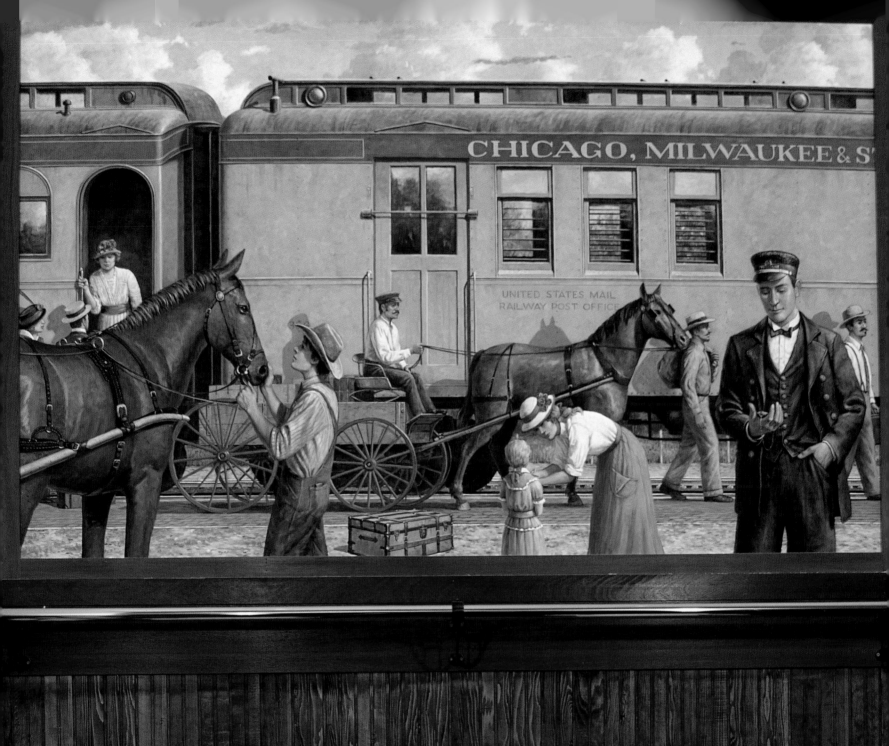

My father was a railroad man, and the stories
I heard from him helped me realize that
people from very different places — ethnically,
politically, and religiously — all depended on
each other when they were on the train.
These people worked closely together and had to
depend on each other. They disagreed
over very profound things. Yet they could
work together and have a lot of respect
for each other.

— Roberta Green Ahmanson

Will Ghormley

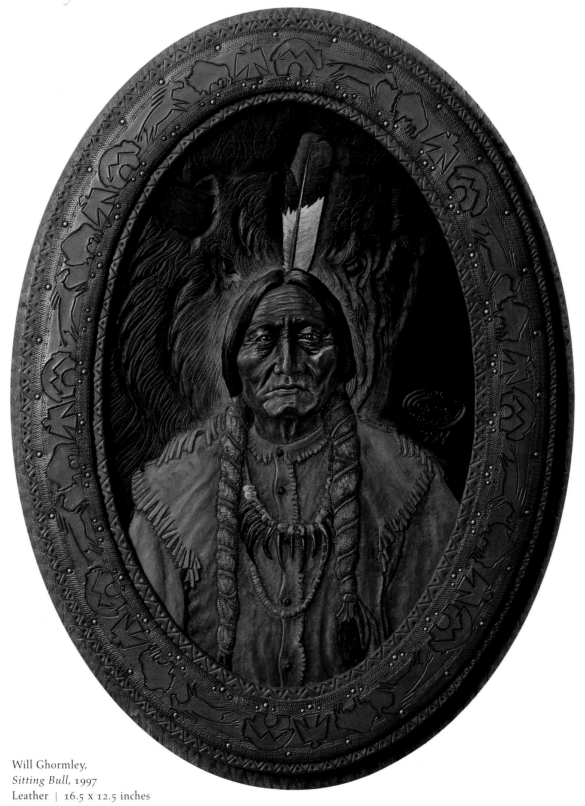

Will Ghormley,
Sitting Bull, 1997
Leather | 16.5 x 12.5 inches

Visual art is like music. It is a catalyst.
It's an entryway. It's a bridge.
It should evoke emotion. It should reach out
and grab hold of people's souls
in ways that they wouldn't ordinarily
be vulnerable and lead them to conclusions.
— Will Ghormley

Will Ghormley is an artist. He's also a cowboy. And he's a man who loves stories, which he relates with a soft drawl and a twinkle in his eye. "The first thing I can really remember about drawing, and specifically about trying to be artistic, happened when I was a child. My dad is a preacher, and I was trying to draw my mother during one of my dad's sermons. I had nothing better to do. I was drawing on the back of the church bulletin, and I worked really hard on it. But when I finished, the woman I had drawn looked mean, and not at all nice like my mother. So, I decided I would put horns on the picture and turn it into the devil instead. That's one of the first things I can remember about art. I didn't take any art classes until my senior year in high school. Then I had a crush on the new art teacher, so I took all the art classes I could take. Good thing I did, too."

The train panels that Will Ghormley created for the Hotel Pattee's restaurant, David's Milwaukee Diner, are so unusual that many people are unable to determine just what kind of medium the artist used. In fact, the panels are made of carved and painted leather. Once that is determined, the next question is always the same: "how on earth did he do that?"

Will recalls an early conversation with the creative team from the Hotel Pattee. "They asked me, 'Can you do train panels?'

"'Well, what are the dimensions?' I asked.

"'Six inches tall and forty-five inches long.'

"Well, I thought, okay. Trains are long and skinny, so, yeah, I can. That should be easy.

"Well, I was wrong. It was not easy. There are nine panels — two in each of the three booths and three along the opposite wall. It was the composition that nearly drove me insane. A normal composition fits in a rectangle and, you know, there are

all kinds of artistic formulas to come up with the perfect composition. What I ended up doing was having, in most cases, three different pictures that are all part of one picture. That meant there were three different focal points to deal with as I worked through the piece. It was a nightmare."

Will Ghormley created the leather room-number plaques, which are mounted next to the guest rooms throughout the Hotel Pattee. Later, the hotel acquired a leather painting he had done of Sitting Bull that now hangs in the American Indian Room. But it is the leather murals in the Challenger Dining Room of David's Milwaukee Dinner that best demonstrate the complexity of his art form.

Ghormley describes the process of making the panels. He first sketched the murals on a long roll of brown paper. Once he was satisfied with the composition, he transferred it onto a sheet of clear Mylar, tracing it with a special pen. "Then, in my mind," he continues, "I am building up dimension, because it is a relief sculpture. I start out with a piece of leather that is laminated to eight-inch Masonite, which gives it some rigidity and keeps it from moving around while I'm working on it.

"I trace out what's going to be in the background and the outline of all the consecutive layers that are going to go on top of that. Then I start building up my other little pieces, tracing them out on separate pieces of leather and then laminating them together. The more of these I've done, the more obsessive I've gotten about it. Finally, once I am satisfied with that — which doesn't happen quickly — I am ready to paint it."

After all the carving is done, Ghormley puts a light wash of burnt sienna across the entire sculpture. The layers of laminated leather are different colors because they come from different hides, so the wash standardizes the background. It also collects darker color in all of the impressions, enhancing the tooling in

Will Ghormley

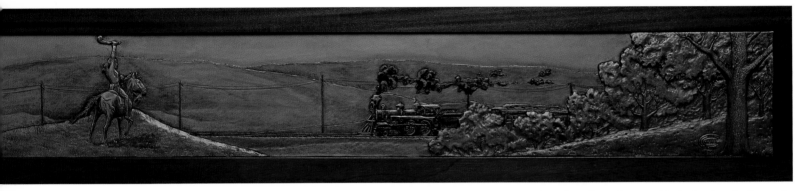

Will Ghormley, *Defiant Indian and Train*, 2000
Leather | 6 x 45 inches

Right: Will Ghormley, *Loading Stockcars* (detail), 2000
Leather | 6 x 45 inches

the leather. Finally, after the color is added, the finished panels are coated in polyurethane, "since kids are going to be after them with their grubby little ketchup fingers."

Ever the cowboy, Will Ghormley has done extensive work for the Roy Rogers Museum in Apple Valley, California. Along with Roy Rogers, his other heroes are Will Rogers and Ronald Reagan. When asked about a dream project, Ghormley barely hesitates. He hopes someday to create a leather painting of Ronald Reagan. "I want to do the one when he was crying," he says, wiping his own eyes, "and taking the chisel to the Berlin Wall."

John Preston, *Dusk: Winter*, 1997
Oil on canvas | 35 x 47.5 inches

John Preston's oil paintings bring to the Hotel Pattee's Hiawatha Dining Room an overview of the passing seasons, as month after month moves across the Iowa landscape. The shadings are subtle; the seasonal changes are subdued. But this artist, highly regarded by his colleagues in the Iowa art community, sees the land, the water, the foliage and trees, the agricultural crops of Iowa with the eye of an intimate observer.

"The paintings at the hotel were all made in places I visit on a regular basis. I try to see them all year-round. Some of them I've painted six or seven times, in various types of weather and seasons. I have a lot of favorite spots," Preston says.

In the Pattee's four-seasons series, John Preston wanted to do something uncommon with the spring painting, so he did not include pastel flowers or pale green leaves, which might have been expected. Instead, he focused on an unusual aspect of Iowa's spring season.

"Around here, spring sort of shows up in the ditches first, because that's where we get the most moisture. The ditches start turning green as the vines and leaves come out. A lot of times our spring doesn't actually happen until well into June. The weather will change and the trees will bud, but the fields don't look any different. So, I wanted to show something about the time when the trees are just starting to bud, and there is a little action in the ditch, where the vines were just beginning to come back."

He goes on to describe the rest of the series. "The fall painting is a classic scene in the Midwest fields, as they are being harvested, and you see all those kind of warm golden colors. Summer, as the painting indicates, gets so green, green, green. The winter painting is in a place southwest of Perry."

John Preston, a calm and soft-spoken man, moved to Iowa from Maryland to attend university in Fairfield. He married and settled down in a cheerful farmhouse, set amidst peaceful fields and trees, at the end of a gravel road. There he paints, and his wife, Cynthia, creates herb gardens. As a transplant to Iowa, he has a deep appreciation for midwestern weather and light. And he enjoys the storms that roll across the prairie.

"Most of the action that happens in a beautiful sky or a storm is seen from a distance. It happens pretty close to the horizon, so it's obscured if you are down in a building or behind trees. I know there are spectacular storms in Maryland, but I just never even noticed them. I got out here and there really wasn't anything to break my view.

"That's a big thing for me — the weather and the light and the seasons. And I like the agriculture — it's not like a vacation landscape, not like going to the mountains or going to the beach. It's where people work. It's ordinary, but it's special at the same time. At least it is to me. Maybe I'm at a certain advantage coming from somewhere else, because if I'd grown up with it, maybe I would be used to it."

More than one Iowa artist spoke of John Preston as a "painter's painter." He is a man who works diligently to perfect his craft, and he inspires others in the process. In recent years he has changed mediums.

"The paintings in the hotel dining room are oils. But from 1986 to about 1996, I was working almost exclusively in pastels. One of my pastels [*Loess Hills near Turin, Iowa*] is on the third floor of the hotel. I switched over to oils because I wanted deeper, darker colors. You don't have much choice of dark colors in pastels. And there's a difference in using a brush, which I enjoy."

Preston likes to paint scenes that might otherwise be overlooked. He often chooses places that someone could easily drive past and not see — what he describes as "plain, ordinary,

everyday kinds of places." He wants his viewer to stop and say, "Okay, maybe I should look a little more closely. Maybe I should use my powers of appreciation."

The setting at the Hotel Pattee, he says, provides viewers that chance. "It was certainly the nicest display that I've ever seen anybody do with my work. It's good to see something other than the standard white gallery walls with the bare wood floor and the track lighting. I think the paintings look better, especially because of all the colors in the wood. The richer, deeper, Arts and Crafts style colors make the paintings look richer by contrast. When you put something on a white wall, it tends to be the dark thing. And I think you lose a lot of the richness of the color."

Preston's enthusiasm for the landscape is evident to those who know his work — his fascination with its subtle changes, the great pleasure he experiences in painting and repainting the same scenes in a variety of ways. "My response to Iowa was just a simple attraction," he reflects. "As an artist, I was attracted to trying to capture the quality and atmosphere and light. It sounds kind of simple — you know, a lot of times artists have larger issues or ideas that they want to work with. But I think I'm probably at my best if I just stick with painting things that attract me.

"I think artists kind of fall into two categories," he concludes. "There are some like Picasso who are constantly doing something new all the time. And there are some like Cézanne who are constantly going out and trying to paint the same mountain from a different angle, trying to add a different aspect to what they've done before. I'm probably more like Cézanne. Once I've explored a subject from every angle, I can only hope I will come out with something that will indicate that I was there. I lived with it. It was authentic to me."

John Preston, *Loess Hills near Turin, Iowa*, 1995
Pastel on paper | 20 x 27 inches

71

John Preston

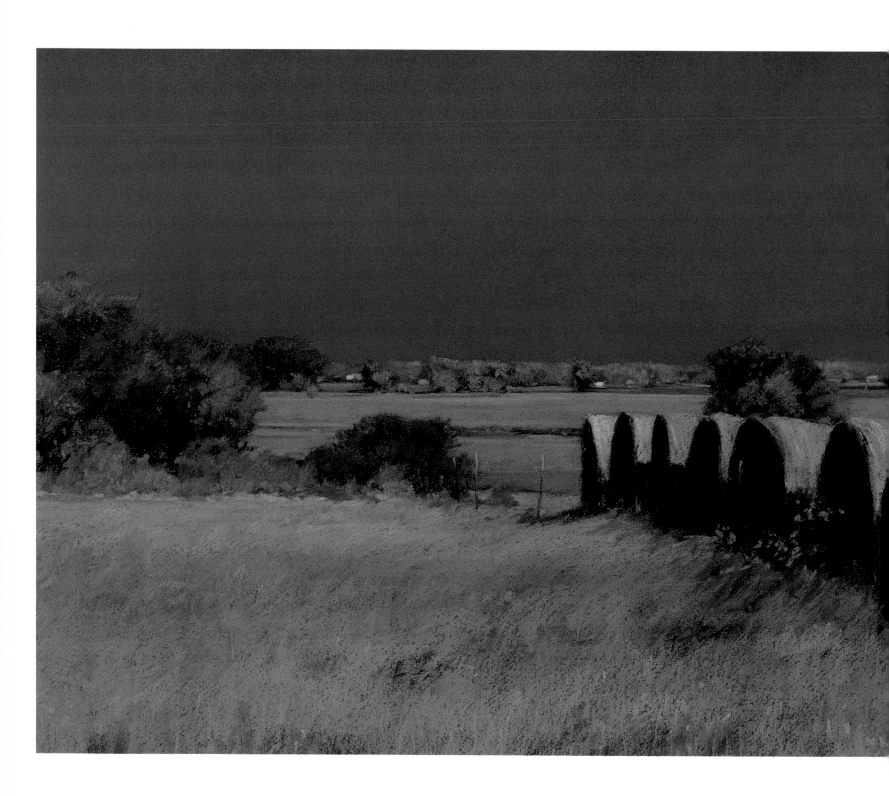

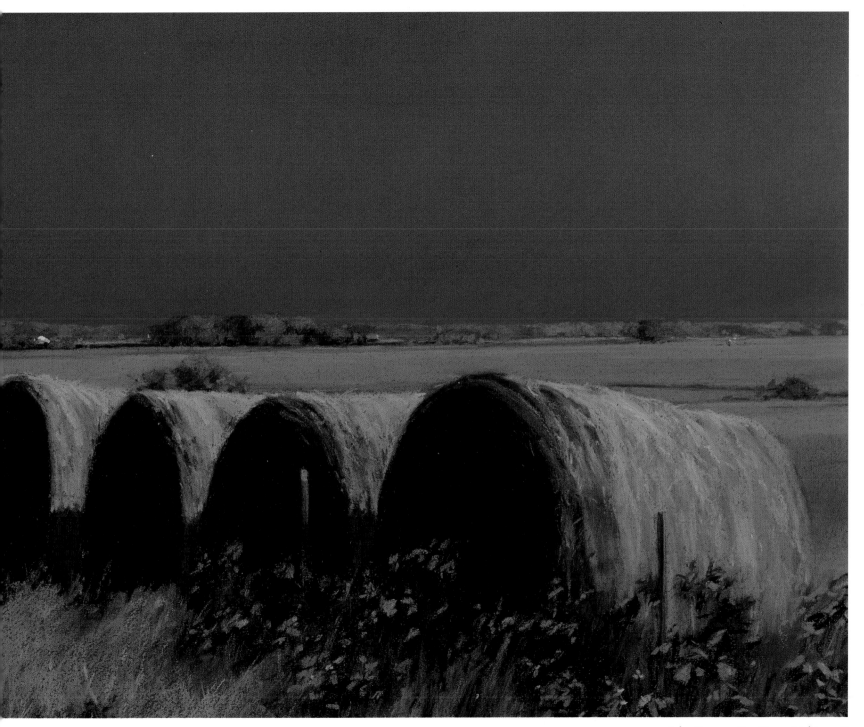

John Preston, *Pre-Storm Light*, 1996
Pastel on paper | 16.75 x 41.25 inches

Dennis Adams, *Des Moines River Valley from Kate Shelley
Bridge North and South* (one of six images), 1998
Watercolor on board | 38 x 36 inches

In David's Milwaukee Diner's Arrow Room is a series of water-color murals painted by Iowa artist Dennis Adams. The idea is to provide the viewer with an impressionistic glimpse out the windows of a rapidly moving train as it makes its way across the Des Moines River Valley. It is an enchanted journey, perhaps the memory of a long-ago train ride, a second look through childhood windows.

Adams recounts the thoughts behind his work. "I was striving to do something that was unique and not photographic in nature, so when the project was finished it would have a definite style to it but would still be light and would counteract the heaviness of the mahogany that was used around it. I wanted to keep the colors in the pastel range. I hoped to capture the view from the Old Milwaukee Road Bridge, which is a stretch of railroad that Roberta Ahmanson's father worked on."

Adams walked across the bridge with a panoramic camera and took photographs of the scenes. After he spliced the panoramic photos together, he worked from that image. Besides evoking impressions of the view from the bridge, he also wanted to give the feeling that the viewer was not stationary. A sense of movement was another goal for his paintings.

The resulting murals provide a splash of color in the Arrow Dining Room and reveal the skill of a multifaceted artist whose work is well known in the Iowa art community. A lifelong resident of his hometown of Woodward, nine miles from Perry, Adams says that his career took a surprising turn some years ago. When he left high school, he wanted to attend art school, but his father was not receptive to the idea. The older man was not comfortable with his son's career choice. So Dennis went to drafting school instead and graduated with the intention of working in architecture.

He recalls the events that followed. "Right after graduation, I was injured in a farming accident and I lost my right hand, my dominant hand. And through that accident — and this is one of those crazy quirks, the way God sometimes works in our lives — I got to go to art school. If the accident hadn't happened, I would probably not be an artist today.

"My life had already been planned out. I'd had an interview with an architectural firm. I was going to be a draftsman. Instead, my life spun around. I got sent to art school through a great state program for vocational rehabilitation. They sent me to one of the best art schools in the Midwest — called the American Academy of Art — in Chicago. A number of years later, they sent me back to the University of Iowa and I got my B.F.A. in painting."

Today, Dennis Adams finds inspiration in numerous locales. He describes the excitement of his heart pounding as he looks at a scene, knowing he must do something with it, longing to turn it into art. And as he paints, like most artists, he is often surprised by what emerges from the canvas. "I like to think I know where it's going, but most of the time I don't. And the ones that usually work the best are the ones that I've been struggling with the longest."

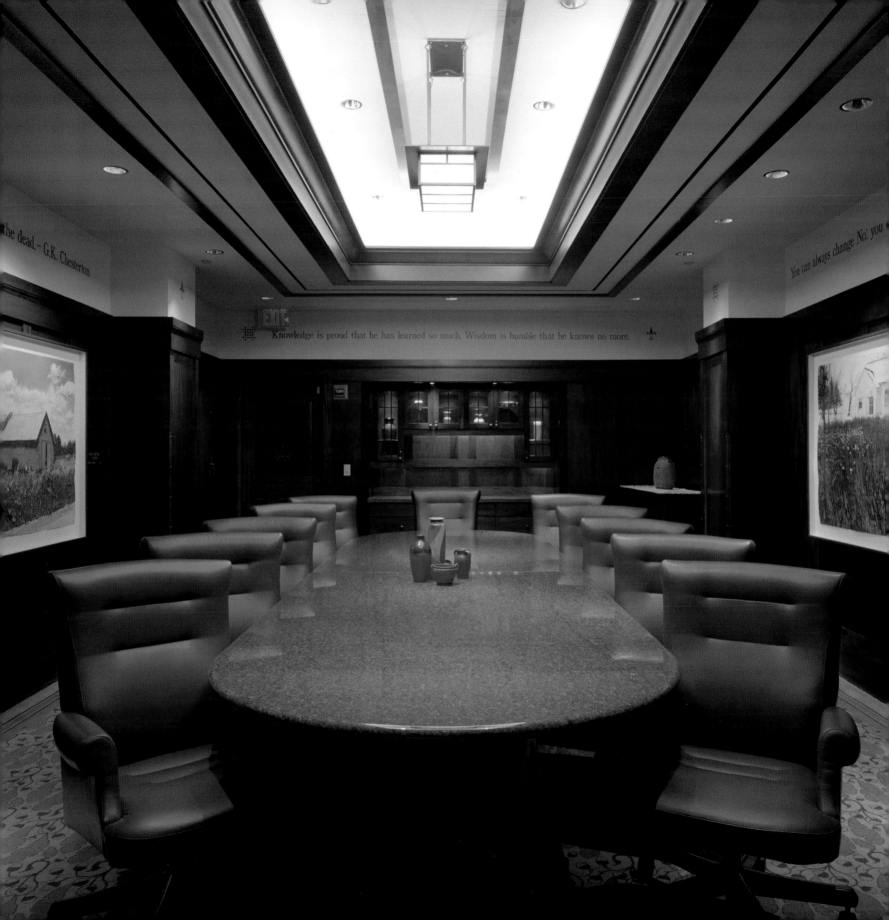

the dead. — G.K. Chesterton

You can always change No; you

Knowledge is proud that he has learned so much. Wisdom is humble that he knows no more.

I made the conscious decision
to select art for the hotel that
was representative of the landscape of Iowa,
so the meeting rooms in the hotel
are all named for either the land or
the governmental structure of the land.

— Roberta Green Ahmanson

Bobbie McKibbin

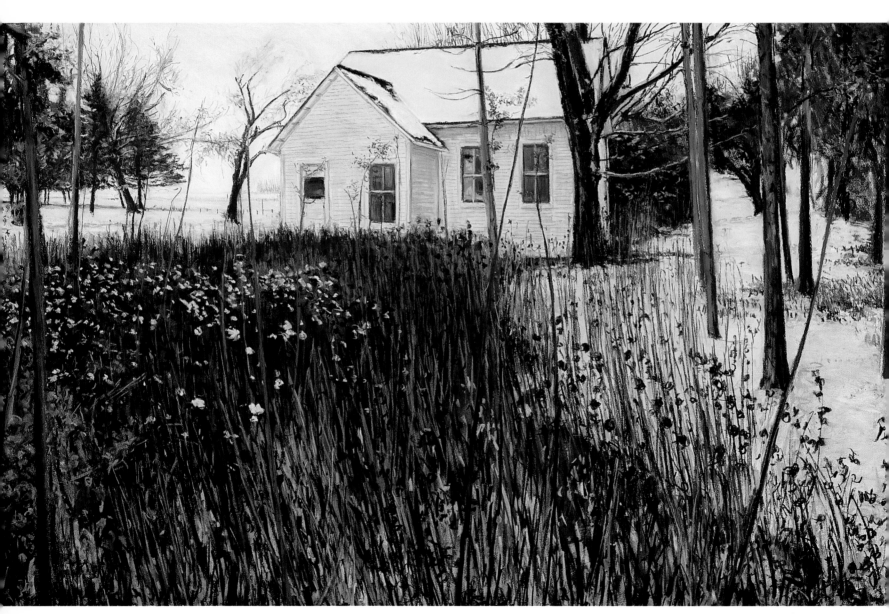

Bobbie McKibbin, *Alton School, Winter*, 1997
Pastel on paper | 40 x 64 inches

Images of two rural Iowa icons — the one-room school and the corncrib — greet guests in the hotel's Dallas County Boardroom. "To be called upon to produce two very large images for the hotel meant a great deal to me," says Bobbie McKibbin, professor of art at Grinnell College in Grinnell, Iowa. "One of the images is a one-room schoolhouse, and as an educator at one of the best colleges in the region, I was delighted to portray that.

"It was equally nice for me, when I was called upon to deal with the project, that it was winter. I went over to the schoolhouse and talked to a young man who was in charge of that area, who took us into the school. It felt like school had been recessed about twenty minutes before, and I had this sense of intimacy and immediacy. It was marvelous. There was a small prairie in front of the school. It had just snowed, and each cornflower had a little dollop of snow on it. Of course, with the snow being very white and the schoolhouse also being white, it was a real challenge to sort of say, 'Okay, what does one do with this?' But what a wonderful image to work on.

"The second image was more or less my choice, and I thought about it long and hard. I thought, Well, in Iowa, we have education, and I think winter is a very beautiful season. But the corncrib acts as a symbol of another important aspect of our state — agriculture. And I selected the red corncrib in summer as a visual contrast to the lightness of the winter scene. The crib is set beneath this amazing sort of blue summer sky and clouds. I thought that the paintings resonated with each other because of the one being extraordinarily intense in terms of color and the other one being almost value oriented. And each of them features an important aspect of Iowa — agriculture and education."

Bobbie McKibbin works in pastels and has a great attachment to them as an ideal medium. "These days pastel has enjoyed quite a renaissance. And I've thought, Why is that? I think it's an amazing medium from the standpoint that it's so accessible. For example, I teach and I have a full teaching schedule. But if I have an hour or two to work, I can come to my studio and my pastels are laid out and I can get quite a lot of work done on the image. Then to leave the studio I simply have to wash my hands, click the lights off, and out I go. If you're painting, even with acrylics, you have to deal with your brushes and so forth and so on. The convenience of pastels is extraordinary."

McKibbin has not always done representational art and for a time worked in a more abstract style. The transition into today's more representational work was inspired by a near tragedy. "Right after graduate school, I discovered much to my dismay that I had a detached retina in my right eye. It required a nine-hour operation to put my retina back together with my eye. I was twenty-four years old, and my eye was shut down for about nine months. During that time, I worked with just my left eye.

"At the same time, I met a young man who painted all these wonderful scenes of southern Ohio. And I looked at my work and felt like it wasn't tied geographically to any place in particular. That's not true of all abstraction, but in looking at my abstract work, I thought it seemed rather generic, like it could have been done anywhere.

"In retrospect, I think that was a powerful situation. Meeting this other painter, along with celebrating the fact that I could still see, was a potent combination. So, I started working from life, delighting in the idea that an image, a painting, or a drawing could be transformed into a person that you loved more than anyone in the entire world, or could be wonderfully

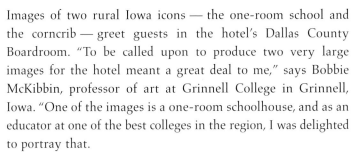

Bobbie McKibbin

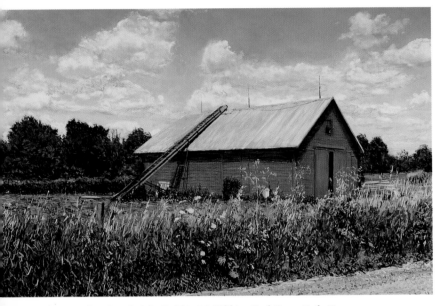

Above and right (detail): **Bobbie McKibbin,** *Red Corn Crib, Summer,* 1997
Pastel on paper | 40 x 64 inches

translated into the street where you lived. The illusion of taking a flat, two-dimensional surface and manipulating it into something very personal and special seemed extraordinarily compelling to me. That was twenty-five years ago, and it's just as compelling now for me — probably more compelling for me now than ever."

Landscape provides an unending source of material for McKibbin's painting. The artist has traveled extensively, recording and celebrating the wonder and diversity in the world. "But one place has had a hold over me like no other, my home — Iowa. The Iowa landscape is subtle, rich, and beautiful. I care about it deeply, and through painting it many, many times, I feel I know it well. In my image-making, I try to faithfully record a sense of place and to create balance and harmony. I believe that human beings are at their best in endeavors like the arts because we are trying to go beyond ourselves."

Ellen Wagener

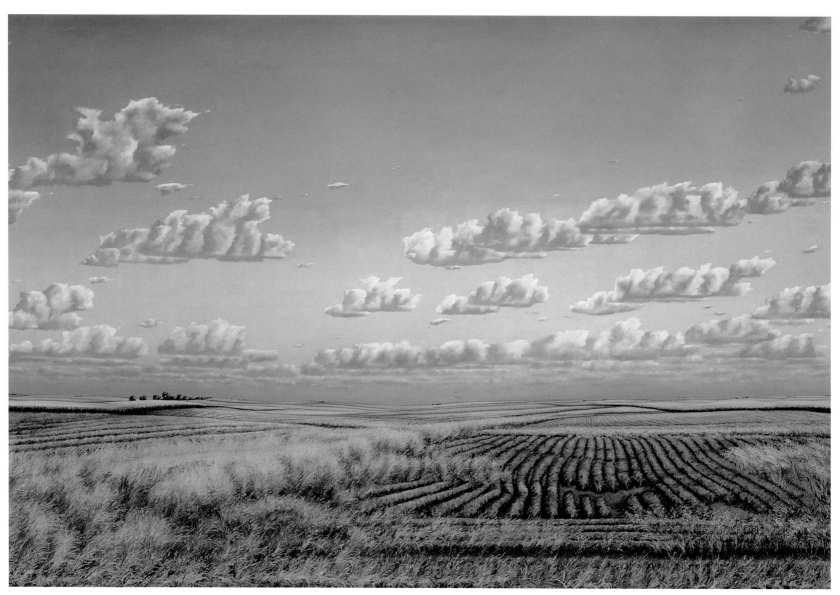

Ellen Wagener, *Landscape, Suite in Three Movements* (one of three images), 1997
Pastel on paper | 38.5 x 57.75 inches

When Ellen Wagener talks about art as a spiritual vocation, she has clearly thought in depth about what she is saying. Her paintings at the Hotel Pattee express her deep reverence for the land of Iowa, her sensitivity to the changing seasons, and her devotion to the beauty of the world.

But for Wagener, spirituality isn't just present in the paintings themselves. "When people see your work, at a museum or a gallery, they see the end product. But for me the spirituality is about the process of making art. It's about how you live in the day. It's about my work being a spiritual communication between God and me. It's an act of worship every day. And when I'm driving around taking photographs out in the country, I can't help but think how grateful I am to be an artist and how happy I am that I get to live my dream every day. It's my spiritual journey. And landscapes, specifically, are the easiest way for me to communicate my joy of life."

Ellen Wagener's colorful home reflects her artistic eye, her love for design, and her concerns for the preservation of rural life. Several personal projects communicate her frustration with commercial intrusions upon the rural scene.

Like many other Iowa artists, she expresses the realization that she must create art — that she has no choice. "Some artists do it for ego," she observes with a smile, "and some do it for fame and some do it for money and some do it for prestige. Living in Dewitt, Iowa, you don't get a lot, if any, of those things. But those are not the things that feed my soul. For me, it's about the fact that I couldn't do anything else with my time that would better suit me than making art. I'm just driven to do it. You know, there were days when we were so poor that we ate chili beans for a week. Still, I would rather do that than take a job and do something that did not satisfy my heart's desire. Doing art is my heart's desire."

Wagener enjoys teaching art to elementary school children, helping them see that they live in "an unusual and beautiful and subtle place. 'You are really living in the middle of a garden,'" she tells them. "'It's a giant garden. And as the corn grows up over your head, you're lower than the garden. And the farmers around here are just giant gardeners.' I try to explain to them about the change of season and color and light, and the different way that the crops look, and that the landscape around here is not something to be ignored while you are driving to the mall. A lot of people, you know they aren't even paying attention to how the colors change."

For Ellen Wagener, self-discipline is an essential component to accomplishment. "Art is all about discipline," she says emphatically. "Inspiration comes fleeting through something like three minutes in the entire day. There are a couple of minutes where you are like, 'I am really enjoying this,' or there are moments of brilliance. But art is definitely not about smoking cigarettes and waiting to get inspired so that you can get to work. There is not enough time in the day for that. You have to get up and get busy. It's like being a dancer. You've got to get up and do it every day, whether you feel like it or not.

"For me, my art is not a job, but it's a mission. And a mission takes your entire energy, from the moment you get up until the moment you got to bed. It's the books you read, it's the food you cook, it's the way you decide how you're going to set up your studio. You take it as a holy mission. I don't think some artists understand that. The ones that don't work very much don't understand discipline. I'm just really, really disciplined about how I work. And discipline turns into productivity, and productivity creates the results that lead you along. You never really get to see where it is you're going if you don't put the time in."

Ellen Wagener

It took Ellen Wagener several years to find her way into the art career she had always dreamed about. As a student, she was led to believe that she could not support herself financially as a studio artist. "I certainly was not encouraged to believe that I could paint for a living. The idea was simply to get a job 'in the arts.' So, I studied art history at the University of Iowa; then I took an internship in Washington, D.C., and I worked in an arts administration office. I was just a glorified xeroxer.

"It was the best thing that ever happened to me because it was the worst four months of my life. After I was done, I said, 'I'm never going to wear pantyhose and high heels again. There is no way in hell I'm going to do this day in and day out.' I hated the pantyhose. I hated the heels. I hated getting dressed up. I hated not making art every day and yet helping other artists make art. So, I applied to the Corcoran and was accepted. After that, I just said 'forget it' to every other job except this."

Wagener savors her work. Like John Preston, she sometimes paints the same scene again and again, captivated by the changes in color and light and the fact that every visit offers a different view. And she describes her wonder at the way her paintings emerge as she works on them.

"It's almost like you have a stone in front of you, and as Michelangelo used to say, the stone carves itself. The same is true of painting. You are just there as the facilitator, allowing the painting to come through you. And until it's finished, you really don't have a clue."

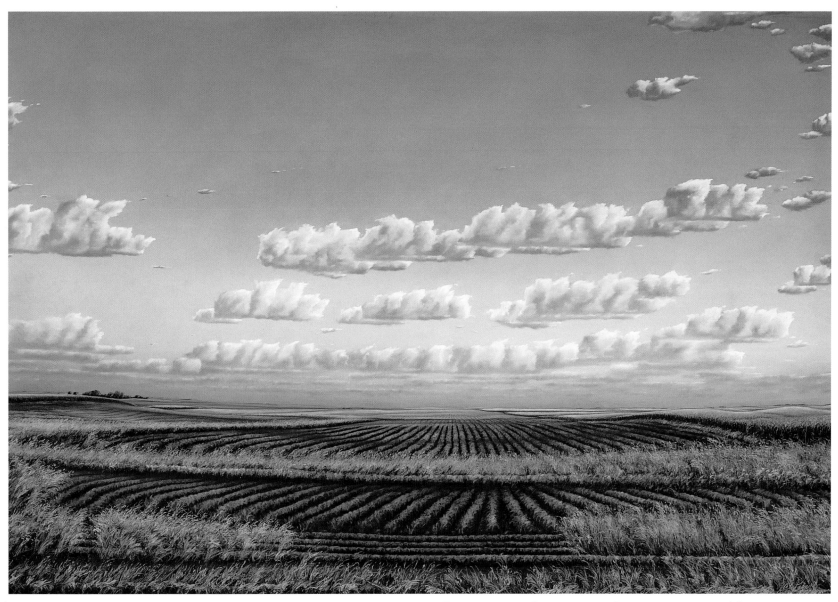

Ellen Wagener, *Landscape, Suite in Three Movements* (one of three images), 1997
Pastel on paper | 38.5 x 57.75 inches

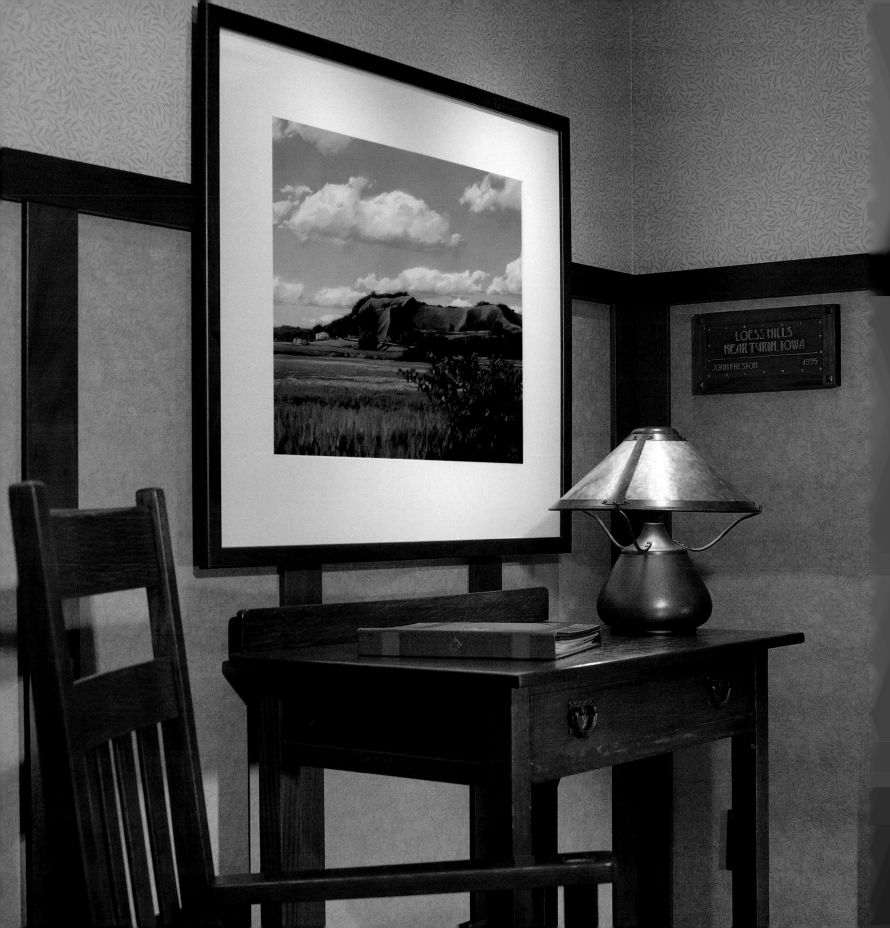

LOESS HILLS
NEAR TURIN, IOWA

JOHN PELSTON 1995

I wanted the art to celebrate the land of
Iowa, the place where the hotel is situated,
to put the hotel in its physical place.

— Roberta Green Ahmanson

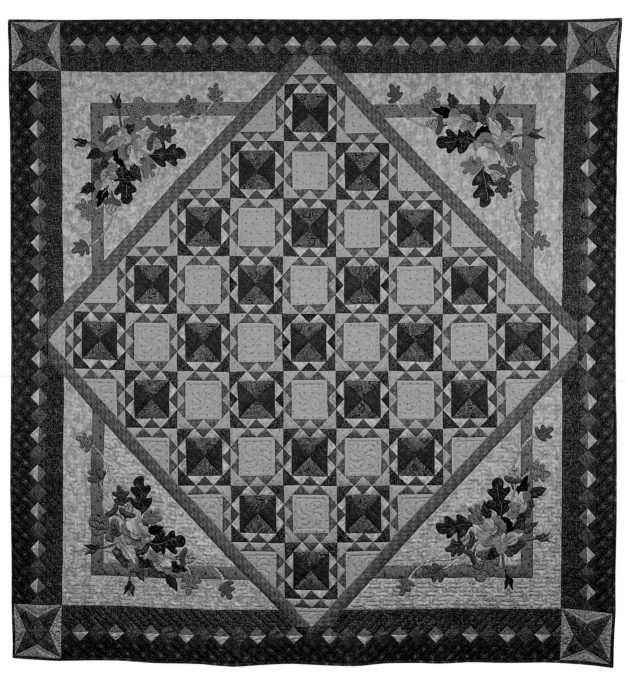

Betty Lenz, *Behold All That Is Iowa*, 1997
Quilt | 71 x 69 inches

Betty Lenz is an award-winning quilter. She has always lived in the Midwest, including many years in Iowa. Her quilts, traditional in style, are reflective of her creative spirit. She has a keen eye for detail and finds inspiration in myriad ways.

"I think most quilters keep a mental file of 'things I want to do someday.' And many times in going to shows you will see a new line of fabric that just talks to you. It just has something to say and it's usually, 'Buy me!' It's really hard to say which comes first. Sometimes it's the design, and sometimes it's the fabric. Both seem to work for me. I never know. But somehow these two things join somewhere along the line."

The quilt Betty Lenz created for the Hotel Pattee hangs in the Nicollet Room and is called "Behold All That Is Iowa." The commission Lenz received from the hotel stipulated only the size and the theme — Iowan, midwestern life. The nineteenth-century quilting block pattern Lenz chose is "Corn and Beans." "Because corn and beans are a large part of Iowa's economy," Lenz continues, "I used that block. It's very graphic, it has lots of triangles, and it also has lots of possibility of working into different fabrics. I was very happy to include in the quilt the oak leaves, which represent the Iowa state tree, and the wild rose, which is the state flower. Growing up, walking back and forth to the country school, I was very familiar with the pink wild roses that grow along the roadside in Iowa. Both of those — the state tree and the state flower — are in the quilt. It's amazing how people from all around the world will say, 'You did that quilt at the Hotel Pattee, didn't you?' I'm very proud to say, 'Yes, I did.'"

As detailed and precise as her quilts are, Betty Lenz does not preplan her work. "Some people quilt from an absolute rigid design — this is going to go here; this is going to go there — and they can't vary from that. Their first thought is the only thought that they have to carry through the whole project. I'm not that way. I design in components. I do the center, and then I see what I'm going to do for the borders and what will work for the appliqué. Then I sit down and see what I can do to enhance that appliqué.

"My quilts happen as they go along. There may be some preconceived idea, but I'm never so rigid that I can't change. Sometimes, some of the best things happen when you totally make a mistake, and it would be a shame not to take advantage of that and to rely on your instinct when something like that happens. After all, that's the creative process."

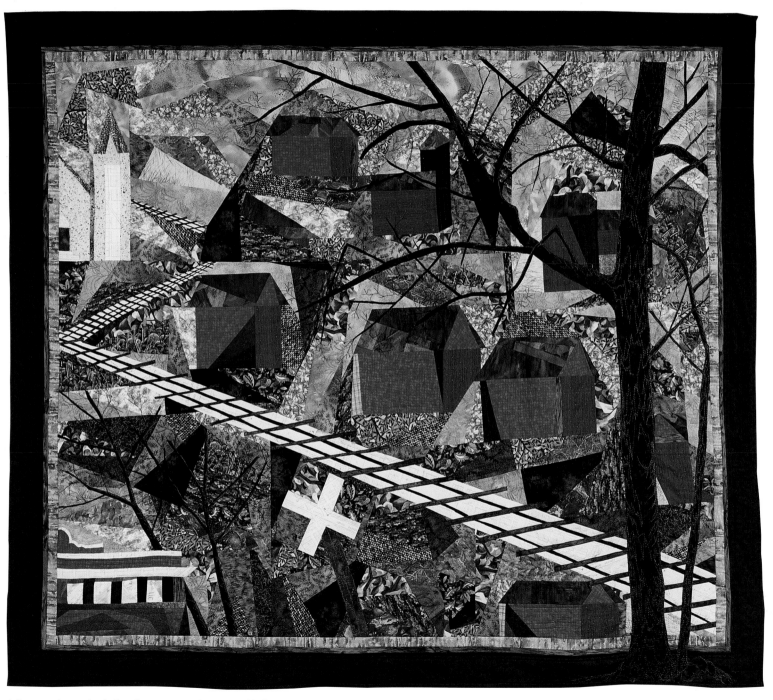

Above and Overleaf (detail): **Murray Johnston,** *All That Is Perry,* 2000
Quilt | 60.25 x 69 inches

I like to think that I am creating art, and the medium just happens to be fabric and thread.
— Murray Johnston

Murray Johnston has painted, she has silk-screened, she has made etchings, and she majored in art history in college. "But," she says, "in 1979, I went to the Birmingham Museum of Arts and saw a Smithsonian traveling exhibition of quilts. I walked into the middle of that room and it was an epiphany. 'I want to do this,' I said to myself. 'I think this is the most beautiful thing I have ever seen.'"

Johnston left the exhibition, went straight to the library, and checked out all the books on quilting that were available. At the time, she could find only three. She later learned that she had been swept up in a quilt revival, which started in the United States in 1976 with an exhibition at the Whitney Museum in New York.

Murray Johnston had never sewn and still does not consider herself to be a seamstress. "I don't do buttons," she laughs. "I don't do hems. I don't make clothing. My mother and grandmother did not sew and they certainly didn't make quilts. So, my first quilt square really, really was 'square one.'"

After teaching herself how to make a quilt block, Murray Johnston hand-made ten traditional quilts over a span of three or four years. "I cut out the little patterns. I hand-stitched them together; I hand-quilted everything." Later, as she attended workshops and classes, she developed an interest in twentieth-century art, which had been her focus in art history, and thus began to study more contemporary quilts.

"I started abstract piecing, just cutting fabric up and piecing it back together again, and then cutting it up again and piecing it back together again, until I would get a design, which was always very abstract, very geometric, that I liked. Then I worked with it; I would quilt it and bind it and hang it up."

After creating several quilts for Roberta Ahmanson's private collection, Johnston was asked to create a quilt for the Nicollet Room in the Hotel Pattee. "I had seen Betty Lenz's quilt and the title of it was 'Behold All That Is Iowa.' And so, I decided I wanted to design my quilt around the town of Perry, call it 'All That Is Perry,' and include in it the theme of the railroad."

A Murray Johnston quilt also hangs in the hotel's Cream 'n' Eggs Room, and a small piece, called "Iowa Sunset" hangs in the Quilt Room.

Johnston is inspired by many things — color, the feel of fabric, and her emotional response to her environment. She describes her process in creating a quilt. "I start building it on the wall. I don't do little diagrams ahead of time, although I have a real vague idea in my mind of what I'm going to do. As I start building it, about a third or halfway through the quilt, the quilt takes over. It's almost like it has a mind of its own and it leads you. And I'm fascinated about where I'm going to end up, because it's usually pretty much where I thought I was going to be, but not always. Usually, it's better."

When asked whether quilting should be thought of as fine art, Murray Johnston nods. "Well, yes, there is a huge, ongoing debate about that. And the quilting community was in an uproar a while back. By now, I think people are kind of saying, 'Who cares? It's wonderful. I love it. Who cares what you call it?' And at the same time, art quilts are demanding higher and higher prices."

Susan (Shoua Vang) Her

Susan (Shoua Vang) Her, *Untitled,* 1998
Quilt | 14 x 16 inches

I want to encourage all Hmong youth,
and especially women,
to take pride in their history and to strive
to be all that they can be.

— Susan (Shoua Vang) Her

Many Americans look back at the Vietnam War as a turning point in their lives. The war's impact on Southeast Asia, however, was even more profound than the upheaval it created in the United States. It cost innumerable Southeast Asian families their loved ones, their families, their homes, and their traditional way of life.

In the 1970s and 1980s, refugees from Laos, Vietnam, Cambodia, and other Southeast Asian countries began arriving, through myriad difficulties and dangers, in North America. Among those were members of the Hmong tribe, a group of Laotian families who fled, often by way of refugee camps in Thailand, to America. Many settled in Iowa and other midwestern states. The Hmong faced their hardships with silence and perseverance, which are looked upon as essential qualities by the tribe. And, thankfully, they brought their artistic talents with them.

The vividly appliquéd and intricately embroidered needlework created by the Hmong is recognized throughout the world. And the work of Susan (Shoua Vang) Her, one of the best-known Hmong handcraft artists in America, is featured in the Hotel Pattee's Southeast Asian Room.

Susan Her came to America in 1976. As a seven-year-old in Laos, like many Hmong girls, she had learned from her mother to do the characteristic needlework of her tribe. Later, as a student in Iowa, she continued to practice the art. One day she made a bookmark for her teacher's Bible. "We are Christian people, and my teacher was a Christian, too. She liked the bookmark so much," Her recalls, "that she took me to the store and bought me a whole bunch of fabric. She told me to make lots of bookmarks so that I could sell them. That's how I began to work professionally."

Susan Her specializes in the complex, labor-intensive Hmong art of *paj ntaub*, pronounced "pan dow," which means "flower cloth," and she was a featured artist at the Des Moines Art Center's Iowa Artists 2000 exhibit. The origins of the art are spiritual; in some ancient cultures the patterns were believed to contain the wisdom required to reach the next life. Today, most Hmong immigrants treasure the work simply because of its deep connection with their culture and customs.

This ornate style of needlework is often found on ceremonial garments; so intricate is the minute stitchery that it appears to have been woven rather than done with a needle. Hmong girls are taught in early childhood the skills necessary to produce *paj ntaub* because its creation has long been considered an indication of desirable feminine qualities; of a patient and diligent nature; of self-discipline; of a creative spirit. And although Westerners may be unaware of the deeper significance of the work, they are drawn to its lavish textures and vivid colors.

Because of her dedication as a mother and her commitment as an artist, Susan Her continues to produce *paj ntaub* and is teaching her daughter to do the same. She does this, she explains, "so that our people's traditions will not be lost."

Above and right (detail): **Susan (Shoua Vang) Her**, *Story Quilt*, 1998
Quilt | 45.5 x 29 inches

Every religious tradition has a view of art.
You can't escape it because the world is art.
The relationship of the sky to the
land to the water, the mountains across
the skyline, the flatness of the desert.
In Iowa you are surrounded by
the art of the land, by the way the fields
are plowed, by the way the crops grow.

— Roberta Green Ahmanson

Millard Sheets, *Rolling Mid-West Farmland*, 1955
Watercolor on paper | 22 x 30 inches

*I think in any art the talent lies not in the skills,
but in what you care about,
how much you love life, how much you believe
in the importance of contributing
The world is just magnificent; you can't paint it
on the surface, you've got to somehow
bleed a little and get underneath it.*

— Millard Sheets, 1907–1989

The relationship between Millard Sheets and the Ahmanson family stretches back over many years to a close and lively friendship between the California artist and Howard Ahmanson Sr. Although Millard Sheets is widely recognized today as a premier watercolorist whose work spanned six decades, he has been described in a biography as a "one-man renaissance."

Sheets's architectural designs are well known in California. In 1954, Howard Ahmanson Sr. retained him to design the Ahmanson Bank and Trust Company building on Wilshire Boulevard in Los Angeles. That initial commission led to his design of more than forty Home Savings and Loan buildings throughout the state. And the two men were more than business associates — they traveled together extensively, and their wives were sorority sisters.

In more recent years, Howard Ahmanson Jr. and Roberta Green Ahmanson have continued the family's friendship with Sheets's late son David and his wife, Susan Stary-Sheets, director of the Stary-Sheets Fine Art Galleries.

Stary-Sheets describes Millard Sheets's vision for the Home Savings buildings he designed. "Millard wanted them to be beautiful so people would feel good about depositing their money there, about having that building as their bank. He wanted customers to see the bank as something like a community center, which he believed that they would do if they had those beautiful buildings in their community. As it turned out, the Home Savings banks he designed were very successful."

Although the Home Savings buildings are very familiar to Southern California residents, Millard Sheets is probably best known for his richly colored and evocative watercolors. Two fine examples — "Rolling Mid-West Farmland," and "Taxco Church"— hang in the Hotel Pattee. His use of color and his sensitivity to mood and locale are well known among art collectors. He began creating art as a child and remained productive for more than half a century.

Stary-Sheets recalls, "I don't think he ever remembered a time when he was not painting. He was a prodigy whose teachers recognized his talent when he was a young boy. When he graduated from high school, his father said, 'Listen, you can go to any college you want. You can go to Harvard and I'll pay for Harvard, USC (University of Southern California), UCLA (University of Southern California at Los Angeles), whatever. But I don't pay a penny if you go to art school.' However, that's what Millard wanted to do. He was being encouraged by some pretty major people in Los Angeles. He'd won his first art prize when he was twelve at the Los Angeles County Fair."

Sheets attended the Chouinard School of Art in Los Angeles, graduating in 1929. From that time on, his unbridled joy in living and keen sensitivity to the beauty of the world propelled him into his prolific career. He created an estimated 4,000 paintings and designed more than a hundred buildings and as many murals and mosaics.

Of Millard Sheets's lasting impact on art and artists, David Scott of the National Gallery of Art in Washington, D.C., has said, "Hundreds of young artists and dozens of communities have been affected by Millard Sheets's vision of the arts as integral to the fabric of life." This indelible impression that Sheets left on the art community reflects his personal philosophy. He once wrote: "I believe the purpose of the artist is to serve his society in the search for reasons to live, rather than primarily expose egocentric demonstrations of relative techniques and talents."

Each of our rooms is decorated to honor
a person, a craft, or a people who made
our town and our state what they are today.
Designed with built-in closets and desks
like those popular with Arts and Crafts designers,
the rooms are finished with fabrics,
wall coverings, furniture, and artifacts that
carry out each room's theme. The William Morris
Room, with Morris reproduction wallpaper,
draperies, and carpet, honors the man
who started it all.

— Roberta Green Ahmanson

Christopher Vickers, *St. George Cabinet*, 2000
Wood | 38 x 60 inches

Those who participate in the discussion of whether crafts-people are really artists need go no further than the William Morris Room of the Hotel Pattee. In a setting that pays tribute to the Arts and Crafts Movement, the visitor encounters some of the most impressive pieces in the hotel — the works of a world-class woodworker, and of skilled needleworkers.

In the nineteenth century, the philosopher and culture critic John Ruskin wrote many books and essays about the relation-ship of morality to art and architecture, one of the most famous called *The Stones of Venice*. Ruskin argued that good human design needed to be moral, to reflect the forms of Nature, to use natural, handmade materials, and to respect the creativity of the craftsmen who designed and executed it. Always, design must remind us of the world of which we are a part. It could not be proud, as Ruskin put it, and seek to ignore or defy Nature.

In the 1840s and 1850s a group of Ruskin's students and fol-lowers tried to put his ideas into action. One of them, William Morris, made a particular stamp on the world of interior design. A painter and a respected poet, Morris eventually formed one of the first true design firms, Morris and Co., and is now best remembered for his fabric, carpet, embroidery, and wallpaper designs. The movement he launched was called Arts and Crafts, and over time it came to change the way houses and their furnishings were designed.

In the tradition of William Morris and the Arts and Crafts Movement, English woodworker Chris Vickers has brought his remarkable skill, love for fine wood, and expertise to the Hotel Pattee. When he was first approached by representatives of the hotel, Vickers was both surprised and delighted.

"I'm all for making beautiful things and am really quite content in my workshop in the garden. But, it is very, very satisfying when you meet someone — and I've gotten to know a few now — who really get a kick out of what I'm doing. They can actually relate, and you know what they are talking about. I get a real buzz from that."

Vickers's father worked with wood, and it was no doubt his influence that first caused young Christopher to pursue his career. "And then at school," Vickers remembers, "I guess I had a natural flair for it because it was one subject I really enjoyed."

Vickers left school at sixteen and took an apprenticeship. As he developed his talent, he discovered the Arts and Crafts style. "A group of us went down to London to see this exhibition, which was great. So was the museum. That was my introduc-tion to the Arts and Crafts Movement. And when I went back to college, they had a fantastic library, so I would look up Arts and Crafts. What was this about? From then on, my interest just grew and grew and grew. I started by increasing my box-making and eventually moved into furniture-making."

Several years later, Vickers heard from the Hotel Pattee. "Roberta Ahmanson asked if I would fancy making some pieces for her hotel. She didn't say how much furniture she wanted. 'Oh,' she said, 'I have a William Morris Room. And I'd like some William Morris–style furniture. Do you have any ideas?'"

Eventually, Vickers was commissioned to create several pieces for the hotel. His first task was to find the appropriate wood. His small, elite group of English woodworkers has its own network of people who supply home-grown timbers, the only ones Vickers uses.

"If someone asks me to make a display cabinet out of cherry, I'll be doing it out of English cherry rather than American cherry. American cherry is very nice, but that's not my thing.

Christopher Vickers

Christopher Vickers, *Morris Chair*, 2000
Wood | 39 x 31 inches

I will use English cherry. Mostly the Arts and Crafts furniture that I'm inspired by was made of English timbers. Of course then you've also got the rain forest problems, you know — ebony, for instance. I use a lot of black wood inlay in my work. But I wouldn't dream of using ebony now. I use English bog oak, which is black."

After two months of intensive research, Vickers worked on the Hotel Pattee furniture for about fourteen months. "I wanted to make the pieces accurate in style and construction as much as anything. The way the pieces were put together is so important — that's part of the Arts and Crafts style. Physically, you've got to join the pieces, and you've got to know how to do it. I had appointment after appointment, going up to London, measuring pieces, looking through books, finding ideas, checking out construction, and looking at different photographs of the same piece."

Vickers describes himself as a perfectionist and admits that it doesn't make his work any easier. "I don't know quite why I am that way, but I know it drives me. The original construction, if it can be found out, needs to be found out. Because I want to do it right. Most pieces that I make these days, I'm happy with, and the customers are totally pleased. Strive for perfection, but learn the human side. There is always something I'm not happy with."

The Vickers house has a workroom and several other areas that are stacked with boards of hardwood in various shapes and sizes. Some of the wood is difficult to work with and yet produces beautiful carvings. It has been said of sculptors that a statue is hidden in a block of stone, and a gifted sculptor can see it there. Vickers says the same about wood. "Occasionally a piece of wood speaks to me and says, 'I'm going to be something special one day.'"

Christopher Vickers and Sonia Demetriou
(painter), *Backgammon Chest,* 2000
Wood | 75 x 38 inches

107

Elizabeth Elvin

As the William Morris Room began to take shape at the hotel, England's Royal School of Needlework was approached to produce a replica of the Daisy Hanging. The wall hanging, originally designed and embroidered by William Morris with help from his wife, Jane, was to be adapted to form window coverings.

Elizabeth Elvin is principal of the Royal School of Needlework located at Hampton Court Palace in England. She was asked to oversee the Daisy Hanging Reproduction Project, and it was to be a formidable task. The hanging was removed from its present location at Kelmscott Manor in England and photographically traced onto acetate. A color match — not to its original shade, but to its present hue — was also produced. The wools for both the background and the embroidery thread were painstakingly matched, and the pattern was transferred to the new fabric.

"It is a blue serge," Elvin recalls. "And we just could not get a serge, but we got a beautiful handwoven wool of almost the exact color." The fabric was shipped to the United States.

Meanwhile, in Iowa, several embroiderers were identified who were interested in the project. During the first week of April 2000, Elizabeth Elvin taught eight women the embroidery stitches and finishing techniques to recreate the Daisy Hanging.

Before she met them, Elvin was concerned as to whether the Perry-area women would be capable of doing the work. "I wanted the project to look really good. I didn't want it to look unprofessional. But the women who came to work on it were just so intense, they were so committed. They were willing to learn, and I was so relieved. In about ten minutes' time, I realized it wasn't going to be a problem at all."

Liz Elvin is an exuberant and articulate spokeswoman for needleworkers in general, and the Royal School of Needlework in particular. She took to Perry, Iowa, a wealth of tradition and history. "The Royal School of Needlework was begun in 1872 by the third daughter of Queen Victoria. This was during the time of the Industrial Revolution, so a lot of machine work — bad machine work — was being produced.

"The founders of the school wanted to bring home embroidery back. And equally, from the social side, a lot of women or young girls had never, ever had to work before, but they now needed jobs, and there wasn't the money around to employ them. So, they were looking for something, some kind of employment that they could actually enjoy."

In England, embroidery had been very popular during the twelfth and thirteenth centuries, and English embroidery of that time was arguably the finest in the world, Elvin says. However, because fabric doesn't survive the ages as well as oil paintings and marble statuary, much of that work has been lost. The Royal School of Needlework not only taught young women to do hand needlework, but it researched numerous stitches that had once been in wide usage, developing a history of old embroideries. During the Arts and Crafts Movement, designs were rediscovered and stitches were redeveloped, many of them by William Morris himself. Once again, handwork was elevated to a place of respect and recognition.

Without a doubt, Elvin says, needlework is fine art. "This is something we are trying desperately hard to get across, because embroidery is an art form rather than a craft. The palette is thread, not paint. The art is in the design and the color."

The women who came together to work on the Daisy Hanging Reproduction represent a tradition of Midwestern art — the art of needlework. The skill many of them learned from their mothers and grandmothers made it possible for them to quickly grasp and perfect the crewel stitchery that Elizabeth Elvin called on them to use for the Daisy Hanging in the hotel's William Morris Room.

The project's women had worked with various forms of art and fine crafts before. Some are seamstresses. Some are painters. Some crochet. Some quilt. They all brought with them, into the Daisy Hanging Reproduction, a commitment to the task and a great deal of enthusiasm for the camaraderie they shared working together toward a common goal.

Mary Von Behren's grandmother was a milliner and a seamstress who taught her granddaughter to sew. Today, Mary Von Behren has not only invested many hours on the Daisy Hanging, but also creates the infants' railroad bibs that are sold at the Hotel Pattee. She talks with pleasure about her work on the Daisy Hanging. "It was a challenge to work with such lovely material. The wool is to die for, and I was very interested in the history of the whole Arts and Crafts Movement. It's wonderful that Roberta Ahmanson wanted to do the William Morris Room as authentically as she's doing it. And it's wonderful that I could be a part of it."

Karla Allen also learned needlework from her grandmother and mother. She finds handwork to be relaxing and does cross-stitch, knitting, quilting, and sewing as pleasurable pastimes. Her then-and-now recollections of the Hotel Pattee mirror those of many Perry residents.

"I remember going into the hotel several years ago. A family was coming to visit, and we didn't have room in our house, so we arranged for them to stay at the hotel. Back then it was a nice place, a pleasant place. But now it's just like going into another world. It's so beautiful — all the artwork, all the woodworking and paneling.

"Since we've started this project for the hotel, it has been such fun to be together without the telephone ringing or someone wanting dinner. We've all really enjoyed doing stitching and having good conversations. But even more, we've really enjoyed the unique opportunity to work on something that plays such an important part in the hotel's ambiance."

Joyce Halling Kelly developed a childhood love for handwork. As an adult, she has taught knitting and crocheting and has most recently been involved in the creation of large crocheted pieces. "I've so enjoyed working on the Daisy Hanging curtain," she smiles. "I found myself working for four to five hours at a time, really enjoying this work."

LuAnn Tuhn is fond of cross-stitch embroidery, but she always enjoys sewing and the creativity it requires. "I like to work with my hands," she says, "and to sit back and see what I have made. I'm especially tickled to look at the Daisy Hanging and know that I had a part in it."

Although Janet Nixon had always enjoyed needlework, when the Daisy Hanging Reproduction Project began, she was at an unusual place in her life. Many of her possessions were in storage, and she was not doing any handwork.

"I happened to see a little article in the paper," she remembers. "It was about the needlework classes. I had no idea all this was going to take place when I enrolled. This project has got me back into needlework, which has always been a really big part of my life. And I've gotten those boxes out of storage and started doing things again, too — things that I needed to do for myself. It's been a very special project for me. I really hate to see it end."

I have loved art all my life,
and I couldn't imagine
not having art in the hotel.
And, it also fits into the tradition of
the Arts and Crafts Movement.
So, the two went together.

— Roberta Green Ahmanson

Imagine a headboard made of a glockenspiel and two saxophones. Or, a lamp fashioned from a trumpet. Picture another headboard made of a unicycle wheel, and a lamp made of bicycle parts. You've just had a glimpse of California artist Rob Brennan's imagination at work in the Marching Band and RAGBRAI/BRR rooms at the Hotel Pattee. (RAGBRAI® stands for The *Register*'s Annual Great Bike Ride Across Iowa, held every July; BRR is the Bike Ride to Rippey, held the first week in February.)

Brennan's artistic career was literally born in the ashes of a tragic fire that swept through Laguna Beach, his hometown. Until that time, Brennan had been exposed to art through his parents' work in art education, and he'd had a deep appreciation for fine art. But the fire changed everything for him.

"On October 27, 1993, my neighborhood burned to the ground. Once the fire started, the inevitable had begun. A few friends and I did all we could to save our homes and those of our neighbors. We succeeded on our side of the creek, but across the way there was really no hope. We all stood and watched people's homes literally vaporize.

"But in that inferno, with temperatures of 2,000 degrees and more, the implements of daily life were transformed by the fire into textures and colors of unexpected beauty. I couldn't help but notice that the things that were left were sad, but they were also very beautiful. And they were made by this power; this force created these things. So out of scraps, which were found among the ashes, I began to create small sculptures which were sold at an auction to help survivors of the fire."

Rob Brennan, Headboard in Marching Band Room, Hotel Pattee

In the days that followed, word spread about Brennan's sculptures. Some of the fire survivors wanted to memorialize the way of life they had lost in the fire that had so devastated their lives; they wanted what Brennan describes as "a sort of gravestone, to commemorate what had happened to them.

"A lot of the pieces ended up with very spiritual significance. I never took it lightly, especially with the commissions. Those were really hard for me to do. I didn't know those people, didn't know anything about their style, and there was nothing representing them in their new homes because their entire history was gone. And I was supposed to create a symbol of their life for them. It was a really daunting task."

Because of extensive media coverage during and after the fire, a gallery in Laguna Beach heard about Brennan's work and displayed a collection of his fire sculptures. Tracie McCloskey, interior designer for the Hotel Pattee, selected several items for her personal use and later contacted Brennan about doing sculptures for the hotel.

"She told me the theme and I thought, How am I going to do a marching band? I was at such a loss to figure something out. I thought of the glockenspiel, which has a nice stylish shape. Finding one wasn't so easy, and they are not cheap, either — all the instruments in the headboard are working instruments. But once I found the glockenspiel, then the rest really kind of came together. The shapes lend themselves to sculpture, like the saxophone shape and the drums and the tubas."

Brennan's unintentional entry into the art world came from his desire to create something worthwhile out of tragedy. "All I wanted to say was that beauty can come from a disaster. That was it. That was my only reason for what I did. The only people I was trying to affect were my neighbors. That was it, and it worked. And for my community, it really did make a difference."

Rob Brennan, Lamp in Marching Band Room, Hotel Pattee

Right: Rob Brennan, Lamps, bedside table, and headboards in RAGBRAI/BRR Room

Mary Kline-Misol

Mary Kline-Misol, *RAGBRAI/BRR Room Border* (Detail), 2000
Oil on canvas

Bicyclists navigate across the landscape into the fresh Iowa morning, finding their way along the border of the Hotel Pattee's RAGBRAI/BRR (The *Register*'s Annual Great Bike Ride Across Iowa/Bike Ride to Rippey) Room. Along with Rob Brennan's innovative furniture designs, Mary Kline-Misol's painting brings to life two of Iowa's best-known annual cycling events.

Kline-Misol's father was a career newsman at *The Des Moines Register*, and her connection with the paper gave her a special interest in the RAGBRAI® event, which is sponsored by the *Register*. When commissioned by the Hotel Pattee to create the border, she decided to produce a visual narrative of the trek across the state and to include landmarks that have become identified with the ride.

"I contacted the *Register*," she says, "and obtained some slides and a few posters as visual reference. My husband and I then spent many hours driving through the back roads in the summer creating a photographic journal of the Iowa landscape. I also scoured the newspapers for possible photos."

Over the years a number of colorful individuals have embarked on the RAGBRAI® journey, and Kline-Misol wanted to include portraits of them. "I was able to do this, and among the faces that look out at the visitors to the RAGBRAI/BRR Room is gentle old Clarence Pickard in his pith helmet."

When he showed up for the first RAGBRAI® ride in 1973, which began in Sioux City, Pickard was eighty-three years old and hadn't ridden a bicycle for quite some time. He rode his used ladies' Schwinn all the way to Davenport, Iowa, in 100-degree weather. His attire for the ride was a long-sleeved shirt, trousers, long woolen underwear, and a silver pith helmet. To this day, many Iowans fondly remember Pickard, and he is now celebrated at the Hotel Pattee.

After finishing her research for the RAGBRAI®, which takes place in the summer, Kline-Miskol began to work on what she calls the "winter ride." She explains, "It is a one-day journey in the first weekend of February. The bundled-up bikers start in Perry and ride to the small town of Rippey. There they take a break and then begin the trip back to Perry. This ride has been appropriately dubbed the BRR ride."

Mary Kline-Misol, who also created the border for the Needlework Room at the Hotel Pattee, cannot remember a time in her life when she wasn't producing some form of visual images. "I was considered a child with an extraordinary amount of energy, and I believe the art materials provided by my parents — paper, paints, crayons, paste, pencils — were meant first of all to be a calming distraction. I would sit for hours and draw the world around me."

The RAGBRAI/BRR mural was installed in January of 2000. As she reflects upon it, artist Kline-Misol says, "I would like to think my father would be proud of my effort."

I am a better painter because of what I do with Sticks, and I'm better at Sticks because I do have a different way of thinking and a more abstract approach to what I do.

— Sarah Grant-Hutchison

It is difficult not to smile when entering the Travel Suite in the Hotel Pattee for the first time. "I have seldom heard a train go by and not wished that I were on it," one painted panel declares. "Traveling is almost like talking to men from other centuries," says another. Brightly colored globes and planets are matched with winged beds and happy people on holiday. The suite's imaginative surroundings are an example of the work the Des Moines design firm Sticks does best.

The firm has been described as a "busy, thriving idea factory that turns out original, custom furniture." But furniture certainly isn't all they do. Whenever they get the opportunity, Sticks' founders, Sarah Grant-Hutchison and Jim Lueders, create environments, which they call installation projects. Besides the suites at the Hotel Pattee, they have also installed their theme-based environments in children's hospitals, public schools, restaurants, daycare centers, and a library.

Sticks employs scores of artists who produce original, handmade furniture and art pieces, all made to order. The style at Sticks is fanciful, with hearts and suns and billowing clouds emblazoned across chairs, tables, mirrors, and other furnishings.

Artists Sarah Grant-Hutchison and Jim Lueders, who serves as Sticks' general manager, have merged their complementary talents into a successful enterprise. Grant-Hutchison began her career in fine art as an abstract painter. Their phenomenal success story began in 1991 when Grant-Hutchison reluctantly designed a simple wooden Nativity, which was later featured in *Better Homes and Gardens* magazine.

She had never attempted a project quite like that before. "I would not have seen myself as a craftsperson, making American craft or folk art of any kind. With a master's degree in Italian printmaking and as an abstract painter teaching in the university, this assignment was completely foreign to me."

To her amazement, she received $35,000 worth of orders for Nativities within a week. Sticks was born.

Lueders met Grant-Hutchison at Drake University in Des Moines. "We started working together on these little things, these little ornaments. And the *folkness* is in our work because I just didn't really know what I was doing in building furniture," says Lueders. "But I knew the basics because I was a contractor and I had a structural sense. So with Sarah's help artistically, I made the structures, and she took over from there as far as whatever needed to happen in color and paint."

Gradually, the couple gathered a group of artists in an old warehouse, operating under the assumption that they would all be interested in something to supplement their painting careers. It took time to put together the right people with the right work ethic. Today Sticks employs 125 people, and of that number, 50 percent are fine artists. Others work in the mill shop, wood shop, and the finishing department.

"Jim and I used to do everything ourselves. In a small business, you get the mail and you open it, you pay the bills, you go to the bank, you market yourself, and you do anything else you have to do. Well, we don't do that anymore. We have a marketing person, we have a sales team of three people, and we have an accountant on site. Fortunately, all that is out of our hands."

They recall their first meeting with Roberta Ahmanson regarding the Hotel Pattee project. "From the beginning she was clearly dedicated to maintaining the history of the hotel's architecture, but she wasn't afraid to integrate our installation work, which had nothing to do with that architecture. If the whole hotel were strictly 'period,' Sticks would not be there."

Sticks™, *Detail from cabinet in Travel Suite,* Hotel Pattee, 1997
Deep-burned and painted wood

Sticks™

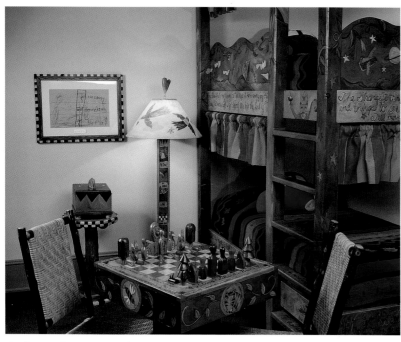

Sticks™, Kids Suite, Hotel Pattee, 1997
Deep-burned and painted wood

Grant-Hutchison continues, "The children's room, which was for her son, was just supposed to be fun. The other room, which she wanted to be a traveler's suite, was supposed to have a theme about traveling. Well, when I was thinking about the Kids Suite, I thought, wouldn't this be a nice way to teach life's lessons? So I covered all the walls with proverbs. Well, that knocked her out. She could not believe it, because apparently her favorite thing in the whole world is proverbs from all over the world. So I just put them all over … the room, and all the little pictures that go with them. She loved it. She's such a spiritual person."

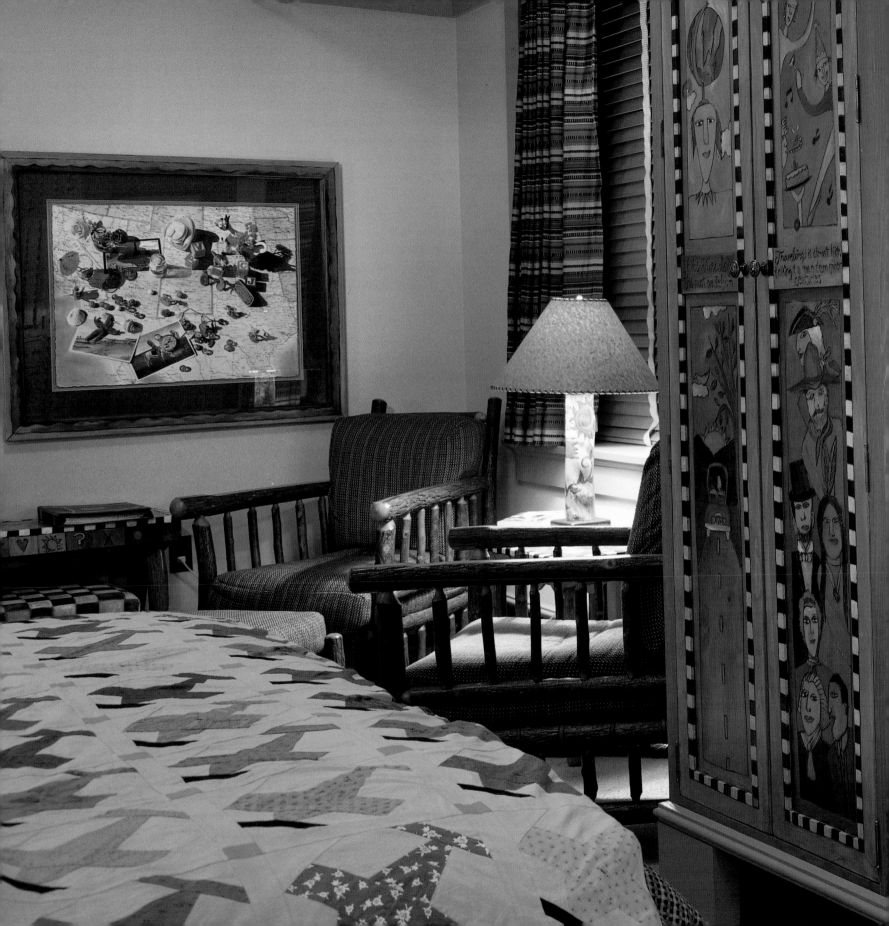

Jan Kasprzycki, *Cathedral Sunrise, Prague,* 1997
Oil on paper | 29.5 x 41.5 inches

When visitors enter Jan Kasprzycki's studio, they enter a world awash in color. His surroundings in Maui, Hawaii, are kaleidoscopic, encompassing a vivid display of images, flowers, and textures in every imaginable hue. Light splashes across lava rock floors and illuminates an array of live orchids, large canvases of flowers, and painted windsurfing boards.

Kasprzycki's paintings transport Hotel Pattee guests to the ports of Greece in the Soumas Suite and to the heart of Prague in the Bohemian Room. All three images are part of a series of paintings of cities from all over the world. Kasprzycki calls the series "Nightscapes."

"In the 'Nightscapes' collection," Kasprzycki says, "I wanted to say something good about the world at the turn of the twenty-first century. So I've focused on the world's cities in the magic hours of the day, including dawn, dusk, and obviously, the middle of the night. I've tried to look beyond the architecture to the heart of the city itself — the food, the music, in some cases the people. These paintings go back to my basic commitment to being real positive about the world. We're still working on the project. I see it going on for maybe another decade. So far, eighty pieces have been created. And someday we're hoping that the work will come back together as a traveling exhibition."

His view of international cities is magical and moving. But nature also inspires Jan Kasprzycki. "I think people bypass nature a lot," he observes. "Everybody can look, but not everybody sees. I like to get people to notice the simplest things, the beauty. Make them stop and look."

Like many of the other artists at the Hotel Pattee, Kasprzycki has been involved in art since early childhood. "As long as I can remember, I've been painting or drawing. The first realization that I loved art came to me as a small boy. My parents had a friend who was an artist. His name was Joe Lane. They used to dump me in his studio when they went to visit him, to get rid of me. Of course, I loved it when I knew we were going there. I would guess I was four or five years old at the time. When I knew we were going to his studio, to this day I can remember the excitement I felt. Joe gave me my own little table and a stack of paper and all the drawing implements I wanted."

Kasprzycki worked for many years in graphic design, on advertising publications for major corporations. He was finally able to relocate in Hawaii and pursue the creative work he loves most. "Shortly after moving to Hawaii, I met a man who owned seventeen freighters. His company was building a corporate headquarters, so for the next several years I traveled the world and painted his ships in action. I painted eighteen major works and over fifty small paintings. Then one thing led to another, and here I am."

Roberta Ahmanson first became aware of Jan Kasprzycki's work during a family vacation visit to Maui. She has since commissioned him to paint family portraits and has added several pieces of his art to her personal collection as well as to the art collection at the Hotel Pattee.

"I think it is an artist's job," Kasprzycki says of his work, "to touch on those realms of the world which others cannot see, and then show it to them."

Jan Kasprzycki

Jan Kasprzycki, *Star Ferry (Hong Kong)*, 1996
Gouache/seriography | 18.5 x 26 inches

Jan Kasprzycki, *Naoussa Harbor, Paros, Greece,* 1997
Oil on paper | 29.5 x 41.5 inches

Amy Worthen, *Sotoportehgi De La Scuola*, 1994
Engraving and roulette (1 of 10) | 9 x 8 inches

Three engravings of Venetian streets hang near the entry of the Italian Room in the Hotel Pattee. They are the work of Amy Worthen, an Iowa artist who divides her time between midwestern America and Europe. "I knew that I *was* an artist, not that I was going to become one someday. My mother was an artist — a painter, art teacher, book illustrator, toy designer — so I had a role model of a working artist-mother and a very supportive environment for my own development," recalls Worthen, who grew up in New York City.

"From the time I was three I was able to attend children's art classes at the Museum of Modern Art and later at the Art Students League, the High School of Music and Art. I often visited museums, majored in art at Smith College, and did graduate work in art at the University of Iowa. I have always been surrounded by art and artists; becoming an artist was a normal thing to do. Growing up, I did not feel as if I saw the world in a different way from other people. It was only later that I realized that my point of view was probably not typical."

From the beginning, Worthen worked in printmaking and drawing. In 1977, she purchased a large etching press, which marked the beginning of her studio. Along with printmaking, she also curates museum exhibitions.

"For many years," she says, "my museum work was part-time, as an independent curator and scholar doing projects for a variety of institutions and publications. During the last three years, I have devoted the majority of my time to my job as curator of prints at the Des Moines Art Center."

Worthen specializes in copper plate engraving, and the public sees only her printwork. Privately, she does a great deal of pen-and-ink drawing, but most of this is not shown publicly.

"I consider these drawings my notes and raw material, my way of thinking."

Individual engravings are not quickly produced. Worthen begins by developing drawings, then transferring the images to copper plates. The engraving is done with special engraving tools called burins. The time necessary to complete an engraving can range from one to three months, or even longer, with the artist working four or five hours a day.

Worthen places her work in a historical framework. "For the greater part of human history, most art was made for a spiritual context. The forms and symbols of art were part of a visual language shared by members of a culture. In the last two or three hundred years, much of this ability to read symbols has been lost, and art no longer has the same function in society that it did in traditional or premodern cultures. Artists today work in a kind of vacuum, and meaning in art tends to be private and obscure. I find that the creation of art still is a kind of magic, a ritual."

Since 1970, Worthen has spent a substantial amount of time in Italy. Over the past ten years, she has lived several months each year in Venice where she often draws in churches. She describes her favorite architectural spaces as having complex arrangements of columns, arches, and vaulting.

"I love the challenge of trying to use perspective and observation to express the experience of being in these spaces. For about five years, I have repeatedly drawn the interior of the basilica of San Marco . . . I believe that we [artists] notice more, see patterns, and take greater pleasure in the visual world. I don't think that artists get bored, because there is always something to look at and think about."

The hotel is the way I thought it should be.
I saw it in my head. I could see lots of it.
I couldn't see everything and there have
been places that, because I couldn't see them,
have been problematic. But, I could see most of
it. And to me, it's a celebration of the God
who is the Creator who made us creative.
Creativity is who we are and to deny
that is to deny a part of our being.

— Roberta Green Ahmanson

I am struck by the diversity and creativity of the wonderful quilts, each one communicating an aspect of the artist's individual life, talent, and response to her roots in Iowa.
— Tracie McCloskey

When Roberta Ahmanson envisioned the art and artists to be featured at the Hotel Pattee, she knew that quilts would be an important component of the hotel's art collection. Along with displaying quilts in the public areas, she also decided that one of the guest rooms should feature quilts, and she turned to designer Tracie McCloskey to help create an environment in which a number of Iowan quilters' works would be featured.

McCloskey, who has assisted Roberta Ahmanson on a number of interior-design projects, including the Hotel Pattee, describes the development of the Quilt Room. "American quilts have always been used as a way of communicating through color, stitch, design, materials, and size, not to mention the group therapy of the quilting bee. Quilts provide a wonderful way to understand the history of women. We wanted to show examples of this art in the Quilt Room, while honoring as many artists from the state of Iowa as possible."

McCloskey points out that immigrants brought quilting to America, using the works of their hands to keep the chill away from their sleeping families, while expressing themselves artistically in the process. Later, during the Civil War, slaves used quilts in the Underground Railroad as a means of communicating to one another. "I love the way quilts express religious, cultural, and emotional values," McCloskey says. "They are not only striking visual pieces but also records of life. As quilter Patti Zwick told me, 'My quilts announce my presence to the world. They enrich my days, they connect me with people who cherish what I do, and they keep me warm at night.'"

While conceptualizing the design direction for the Quilt Room, McCloskey came up with the idea of combining quilt squares with full-size quilts. When she commissioned the squares, the only requirements were that the squares could not be any larger than sixteen by sixteen inches and that the person submitting the quilt square be from the state of Iowa. Twelve quilters responded. Each square represents its artist's personality and particular approach to quilting, and their diversity is striking. Velga Easker's quilt is made out of postage stamps. Gloria Zmolek's is fashioned of origami farm animals. Some are comprised of traditional quilt designs. Others are impressionistic and freeform.

McCloskey points out that each of the women whose work adorns the Quilt Room brings with her a strong sense of her handwork's history and a commitment to its value. Artist Sugar Mark seems to speak for them all when she says, "I quilt today for the sheer enjoyment, and because this American art form is a lovely, silent communication with the past."

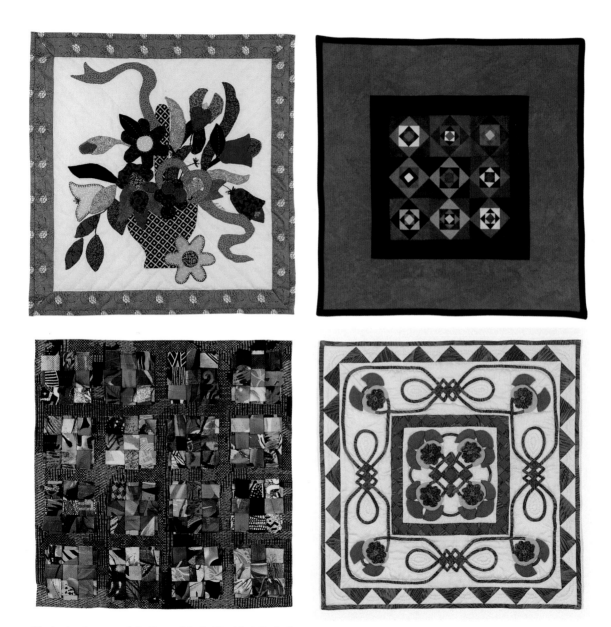

Clockwise from top left: Sugar Mark, *Untitled*; Kathyl Jogerst, *Amish Square in a Square*; Linda Hungerford, *Celtic Glade*; and Karen Godecke, *Forest Floor-Fall*

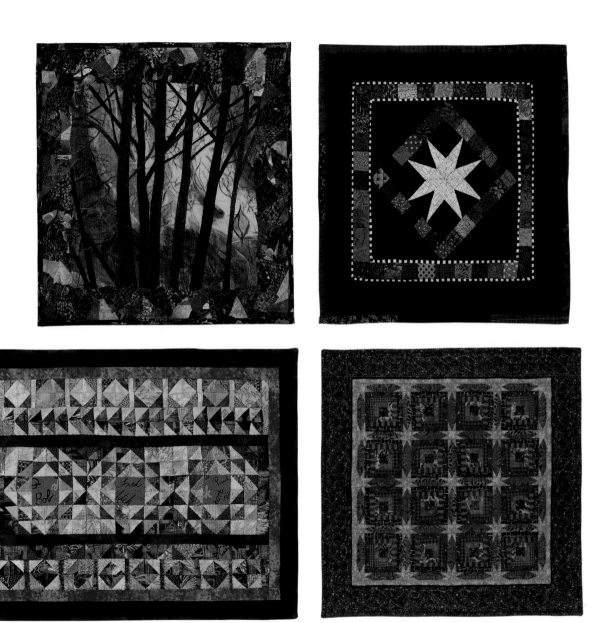

Clockwise from top left: **Murray Johnston**, *Iowa Sunset;*
Patti Zwick, *Miniature Mosaic;* Helen Jacobson, *Stardust;*
and Jenean A. Arnold, *Corn and Beans*

Tracie McCloskey

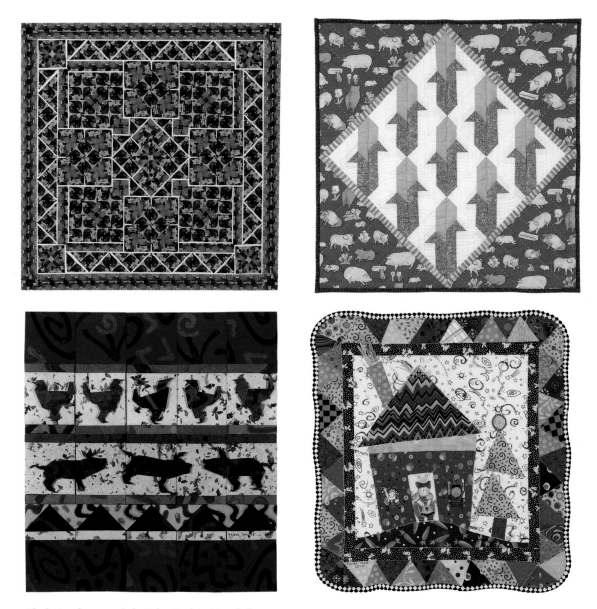

Clockwise from top left: Velga Easker, *Untitled;*
Ellen M. Heywood, *Iowa Corn No. 15;* Trish Koza,
The Joint Is Jumpin; and Gloria Zmolek, *Untitled*

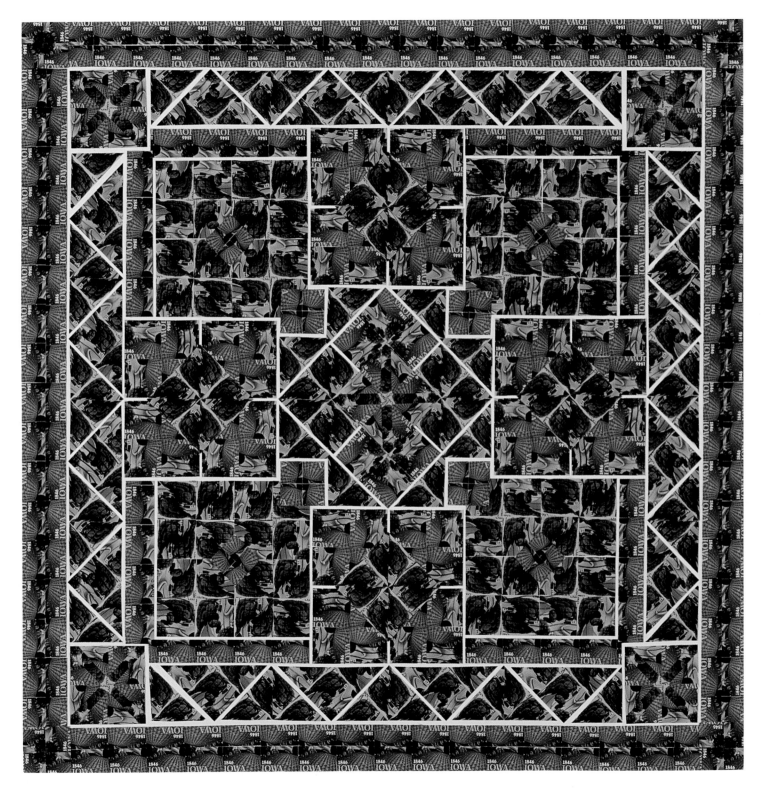

Velga Easker, *Untitled,* 2000
Quilt made from cancelled Iowa postage stamps | 16 x 16 inches

JoAnn Belling

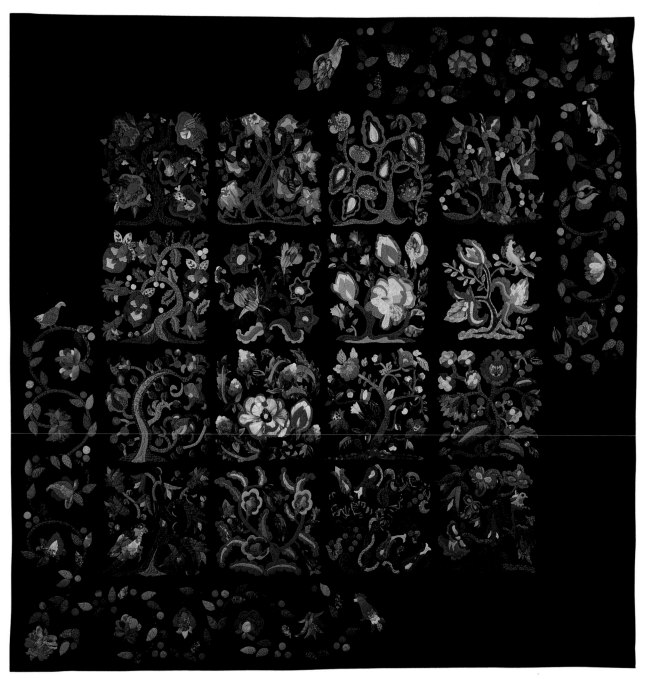

JoAnn Belling, *My Jacobean Garden*, 1999
Quilt | 96 x 96 inches

Displayed in the Quilt Room at the Hotel Pattee is an unusual and dramatic quilt called "My Jacobean Garden," created by JoAnn Belling. First-prize winner at the 1999 Iowa State Fair, the quilt features brilliant flowers and birds hand-appliquéd on a black background. Innumerable hours and hundreds of fabrics went into its creation. "It was nine years in the making," Belling recalls. "Jacobean is a particular style of floral appliqué design, and because many flowers and birds were incorporated into this quilt it seemed fitting to call it 'My Jacobean Garden.'"

"My Jacobean Garden" was, in fact, one of four Belling quilts that received ribbons at the Iowa State Fair in 1999. Two of her quilts were also First Prize winners there in 1995. But Belling is not content to limit her creative efforts to quilting. She presently devotes a substantial amount of time to another artistic medium, photography.

She explains, "There are actually many similarities between these two art forms as far as the use of color, line, design, composition, mats and borders is concerned. In fact, I have done some form of art all of my adult life, including oil painting, macramé, embroidery, crocheting, knitting, sewing, beading, crewel, as well as quilting and photography."

Belling and her husband Tom have worked together in the photography business for forty years. She earned her master of photography degree in 1992 from the Professional Photographers of America and her craftsman degree for public speaking in 1995.

But despite her success as a photographer, for the past thirty-six years, Belling always found time for quilting. About her work schedule, Belling says, "I try to quilt every day. Of course, more progress is made on a project when I stick to one at a time. However, sometimes a wonderful idea comes flitting through my mind and impulse takes over. I simply have to stop and make a few squares, draw a design or pick out some special fabrics. And I don't let myself feel guilty over this detour. I know that I will get back on track with the main project another day."

JoAnn Belling sees art of every kind as a way of bringing beauty and personal expression to the world. She first began to recognize her own artistic capabilities as a young schoolgirl. "Artists see nuances which are generally overlooked by the rushing crowd. I became aware of seeing the world differently even in grade school. My mother, who was my teacher in rural school for most of the pre-high-school years, had a wonderful inspirational and motivational method of teaching. Once we students finished our assignments, we would have the privilege of doing art projects. And we all received heaps of praise for our work, regardless of the medium used or the ability of execution.

Like many of the artists whose works are displayed at the Hotel Pattee, JoAnn Belling draws both ideas and inspiration from the natural world. "I have learned so much from observing nature," she reflects. "God truly did a marvelous work in the beginning, and that marvelous work continues so that each day and each season brings new beauties. Art comes from what is viewed and thought about, working its way inside, and then working its way out again in some tangible form."

Elinor Noteboom

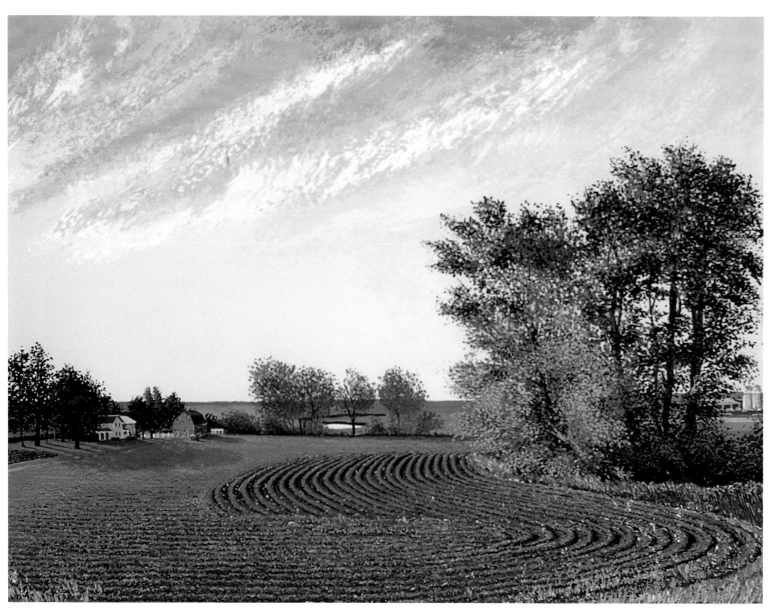

Elinor Noteboom, *Floyd River Farm*, 1984
Screenprint hand-pulled by artist | 23.25 x 31 inches

Elinor Noteboom sits amidst the crimson geraniums in her sunny studio and recalls the Iowa childhood that provided the backdrop for a lifetime of artistic development. "I was born on a farm and I ran barefoot in the dust and the mud and the cornfields and the wheat fields and the clover ditches until I was thirteen years old. All my activities were absorbed with that.

"I loved the sunsets when I was a little girl. I'd sit on this big gate and watch the sun go down over and over again. And I started to be captured by the serenity of the fields. Mostly it is a design element for me. Every field is interrupted with water or bushes, or different light from a different direction, or a driveway. No field is the same. The combination of forms and colors is endless, but it is mostly green. This yellow green that is so Iowa — I get it into my pictures every once in a while."

A woman who has invested a great deal of time in spiritual reflection, Elinor Noteboom comes from a Dutch Calvinist culture and has thought for many years on the relationship between faith and art. She has wrestled with the notion that the arts are superfluous, something to be put aside for the greater good, something to be sacrificed for the sake of more "useful" occupations.

"I lived like that until I was forty, and then I said, 'This isn't right. I have a gift and I could be praising God with it.'"

Noteboom looks upon artists as unique individuals who have a unique view of the world and a creative approach to life's challenges. "If you are an artist, you approach problems creatively and see four solutions where others may see only one. I think it's a gift. Some people seem to have it and some don't. Maybe it's like a musical gift, or, I have a dear friend who says, 'I have a gift for money.' He is very creative with money and he uses it beautifully. But art is a gift that needs to be used. It can praise God and it can unite people."

Although her earlier works were primarily of Dutch life, biblical scenes, and landscape, in recent years Noteboom has moved toward a more abstract approach to her art and is working on a series of large paintings that rely on texture, form, and color rather than realistic representation.

"My method of working now is to start out realistically. Then I put that all away and I move into more free abstractions. There is a spiritual geography here. Somehow, I may be wrong, but people say that Iowans are gentle and midwesterners are low-key and that sort of thing. I think it has something to do with sitting in this garden all the time. And driving in it. And living in it.

"In 1984, my husband and I went to Japan and walked around those wonderful Japanese gray-stone gardens. When I got home and we were riding around Iowa, all of a sudden the little farm fields seemed to strike me in a similar way to what I'd seen in Japan. The more I thought about it, the more I wanted to pull the two together, because one of the most beautiful accomplishments of successful art is when you bring extreme opposites together, like East and West."

Elinor Noteboom has been a teacher. She is a wife and a mother to her three children. She has consulted with experts at Yale University on the history of printmaking. She has worked with Christian artists and served her church through her artistic endeavors. She has shown her art at fairs and in Iowa galleries for many years. Her work has been displayed at the Des Moines Art Center, and for some time she had a gallery in Sioux Falls. She has brought an artist's touch to every aspect of her life.

"I have a couple of pictures that I feel are still successes, that I feel good about. I'm glad I did them, even though they are not quite what I envisioned. But I'm most excited about a coming

Elinor Noteboom

Elinor Noteboom, *Festival IV – The Dance,* 1981
Screenprint hand-pulled by artist | 21.875 x 16.375 inches

exhibition that I'm preparing for right now. I'm excited about it because it's my first successful combination of Iowa fields and Japanese gray-stone gardens.

"When I look back now, I see that I have been among 'the first to bring the Muse into my own country, to my own people, to my father's fields', as Virgil put it in his Georgics. Now that I am immersed in painting these fields, I find in them the comfort of my ancestors and the liberating freedom of my childhood. They exist always at the edge of my consciousness, a kind of prolonged tranquility. The mesmerizing linear patterns speak to me like handwritten notes from the Creator. Somehow there is a spiritual reality behind these natural forms. As artist Kathleen Morris has written, 'The flow of the land, with its odd twists and buttes, is like the flow of a Gregorian Chant that rises and falls beyond melody.'"

Elinor Noteboom, *Do Come In*, 1985
Screenprint hand-pulled by artist | 11.88 x 11.88 inches

Bill Luchsinger/Karen Strohbeen

On the roof of the Hotel Pattee is a garden. It is not a traditional garden, filled with fragrant flowers. It is a garden of the imagination, playful and fantastic, created by two people who understand a great deal about both art and gardens.

Bill Luchsinger and Karen Strohbeen, who fashioned the "Animals, Flowers, and Stars" sculpture in the East Roof Garden, first met in the design department at Drake University in Des Moines, Iowa.

Strohbeen describes their varied art careers. "I was at Drake taking pottery, ceramics, and printmaking, which I like to do because I like multiples. Then I learned how to do lithography and met Bill again and we worked together. Lithography takes two people to do it, so we bought a printing press together and then we got married."

Over the years, the couple has continued to produce art in numerous media — prints, tiles, paintings, fabrics. During one discussion about a piece of art they had seen, which they describe as an "ugly, black, and violent sculpture," Strohbeen and Luchsinger talked about sculpture. If they were to do it, what kind of sculpture would they create? One thing led to another. "We started making six-foot flowers," Strohbeen recalls. "And they were real fun. They were real bright colors and they were made out of aluminum."

Luchsinger adds, "We moved right into aluminum very early. It doesn't rust. It's lightweight. We could work with it ourselves."

Strohbeen continues, "And what is fun is that we worked together. Then Roberta Ahmanson came up with a project. She wanted to put a garden on the roof of the Hotel Pattee. Of course her enthusiasm was contagious. I think she got everybody psyched up to do it and to make it really wonderful."

At first, Roberta Ahmanson had envisioned an actual garden. Because Strohbeen and Luchsinger are gardening experts, with their own PBS show called "The Perennial Gardener," it would have been logical for them to design an actual rooftop garden. "But," Bill Luchsinger continues, "to maintain it would be very difficult in Iowa. It really wouldn't look good a lot of the time. And people had to go through the window to water it and care for it."

Strohbeen and Luchsinger elected, instead, to create the feel of an enchanted garden, and so it was that the magical animals and stars and flowers were designed and installed. Animals, stars, and flowers, such as those in the hotel garden, despite their simple lines, require hours of creativity and physical work. The process is not a simple one.

Karen Strohbeen produces what she describes as "thousands of drawings. I just let them come out." Bill Luchsinger looks at the drawings and, like an editor, eliminates all but the ones that will work best.

"Then," Strohbeen says, "we create a blown-up photograph and make the patterns. From then on it is just a lot of fussing to make it all work. Maybe we'll make a cardboard mock-up if they are real complicated. Then we actually make them and paint them. It's a long process."

The result of much hard work is sheer joy. Thanks to the creativity of two Iowa gardeners — who also happen to be sculptors — the Hotel Pattee has an imaginative roof garden than never freezes in the snow, never has to be watered, and never gets too much of the intense Iowa sunshine.

Karen Strohbeen and Bill Luchsinger, *Animals, Flowers, and Stars,* 1997
Painted aluminum | various sizes

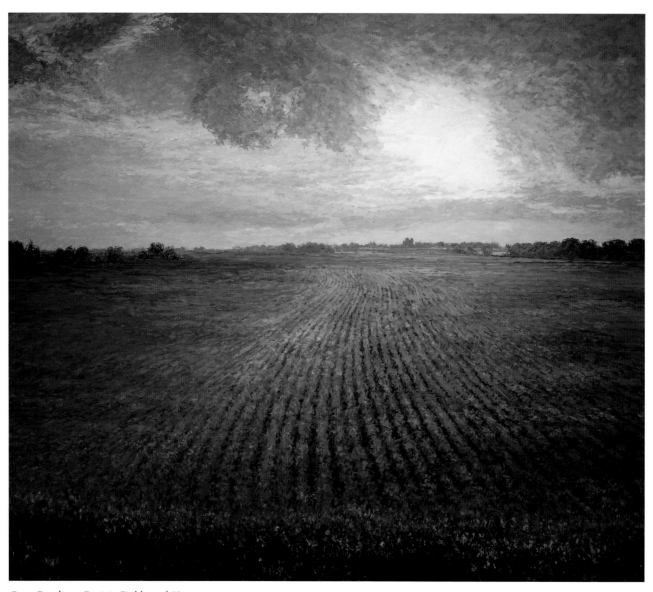

Gary Bowling, *Prairie Fields and Horizon*, 1997
Oil on canvas | 84 x 102 inches

Gary Bowling's sunlit painting, "Prairie Fields and Horizon," dominates the Hotel Pattee's third-floor landing. Its sunlit, golden beauty captures the artist's love of the Midwest and typifies his awareness of contemporary art and theory. Bowling is a highly educated painter who has taught extensively and has a profound understanding of his vocation.

"Someone I met once said that to appreciate an area like Iowa you have to get away from it for a while. Then when you come back, you see it with a fresh vision. I kind of think that's true. For some time I was out of the area, not looking at the landscape very much. I was living in Arkansas, and I had just started developing an interest in landscape theory. Some friends of mine and I would go out to the rivers and parks and the mountains in northern Arkansas and paint and draw and do some photography. During that time, I developed a real sense of what that landscape was about.

"When I first went to Iowa, at first it just looked like a lot of cornfields. But, after I lived on a farm for a while, I started seeing things that were interesting in the patterns of the Iowa landscape. I learned that if you sort of stand back and are quiet, if you give yourself time with something, the nature of it will start coming through. And that's what happened on the prairie; I saw a subtle palette, and a palette that had a lot less contrast range in it that I'd been used to. I started appreciating central lines that move across an area, that are more horizontally undulating. The patterns aren't very distinct; they are very fuzzy."

Bowling talks more about his interest in light and atmosphere when he describes the Hotel's painting. "At some point, as the sun is getting further on the sky, it just sort of evaporates a hole through that atmosphere and it takes on a kind of a real, almost a physical kind of substance. It's almost molten. I accommodated that sort of sky interest to a foreground study that seemed to be appropriate to cornfields and hay fields."

Gary Bowling's large and busy studio stands behind a white frame house in Lamar, a Missouri farming community located on a dividing line between prairie and rolling hills. The studio is filled with light and life, with paintings in various stages of completion, and photographs of his wife and children.

In many of his works, the artist has skillfully juxtaposed landscape with images of human life. He has painted such things as the divisions and contours of asphalt roads crossing farmland, the flat planes of road signs played against the curve of windbreaks, tensions between landforms and heavy clouds, and power lines creating interesting geometric shapes.

"When I first started moving back into landscape work," Bowling explains, "I was teaching, and it was a job that consumed all of my time. I'd go to school early in the morning and I'd get home late at night. The only time I would get out is if I had a meeting I had to go to out of town. So I'd be driving down the highway, and I started photographing the highway a little bit, starting thinking about what is so neat about the highway, and how it takes you forever. I studied orange and white construction devices and road signs and things like that. I thought they were really interesting, and so I did a series of drawings and a few watercolors and then some paintings that incorporated these things. And I thought, well, these are pretty neat."

For Bowling, art is about qualities that lie beneath the surface of life. "Art should distill for us things that are hard to grasp. As we pass through our world, we are sometimes hard-pressed to put our fingers on experiences and emotions. Art makes it possible for us smell its essence. We can have a sense of 'Oh, yeah, I know what that is.' And we still might not be able to put our finger on what it is that we're after, but it's not invisible any longer. At least we've got an inkling."

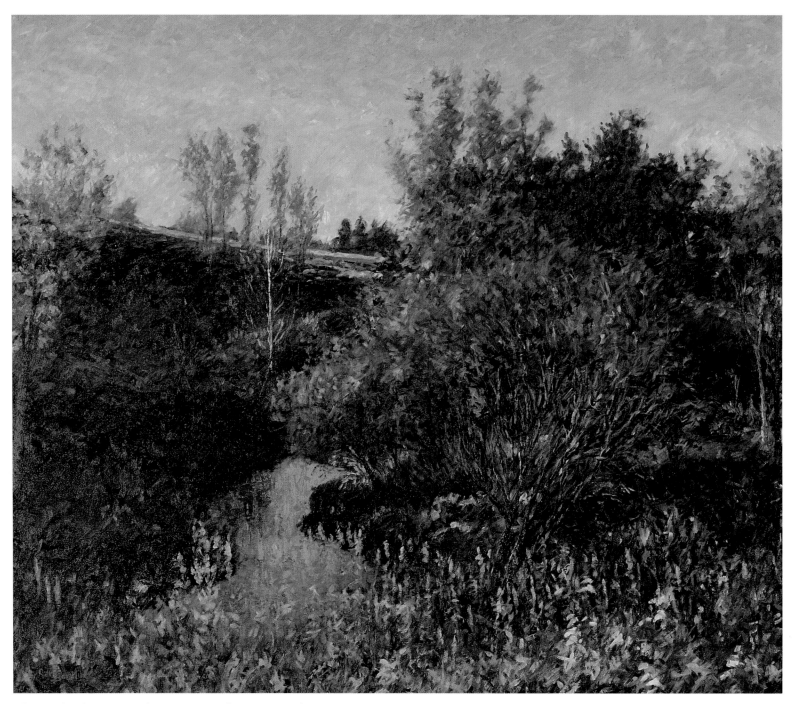

Above and right: Gary Bowling, *Screens and Draws Diptych*, 2000
Oil on canvas | 44 x 52 inches each

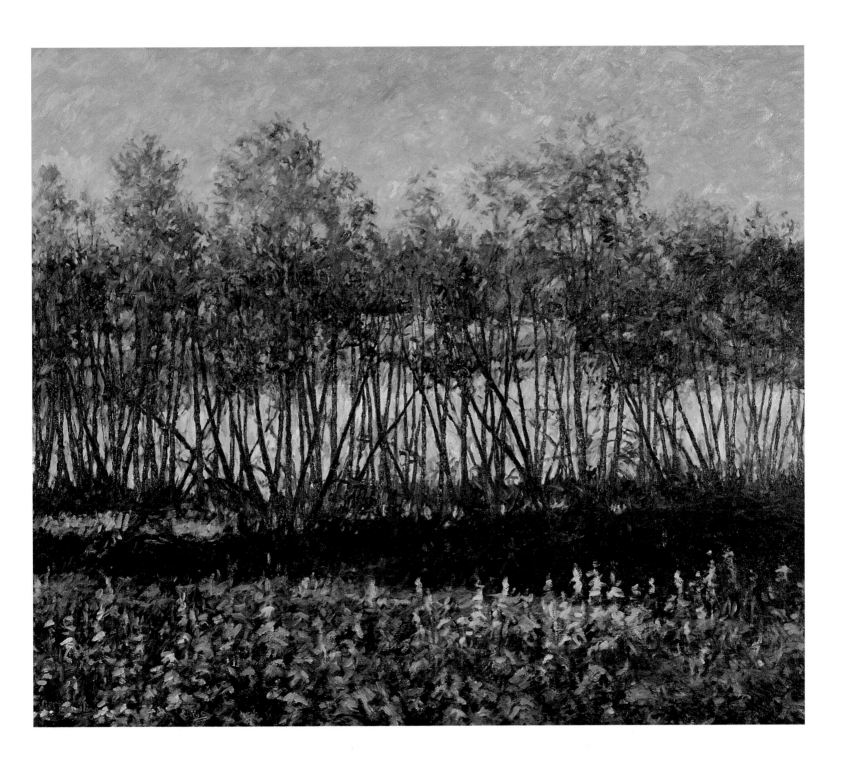

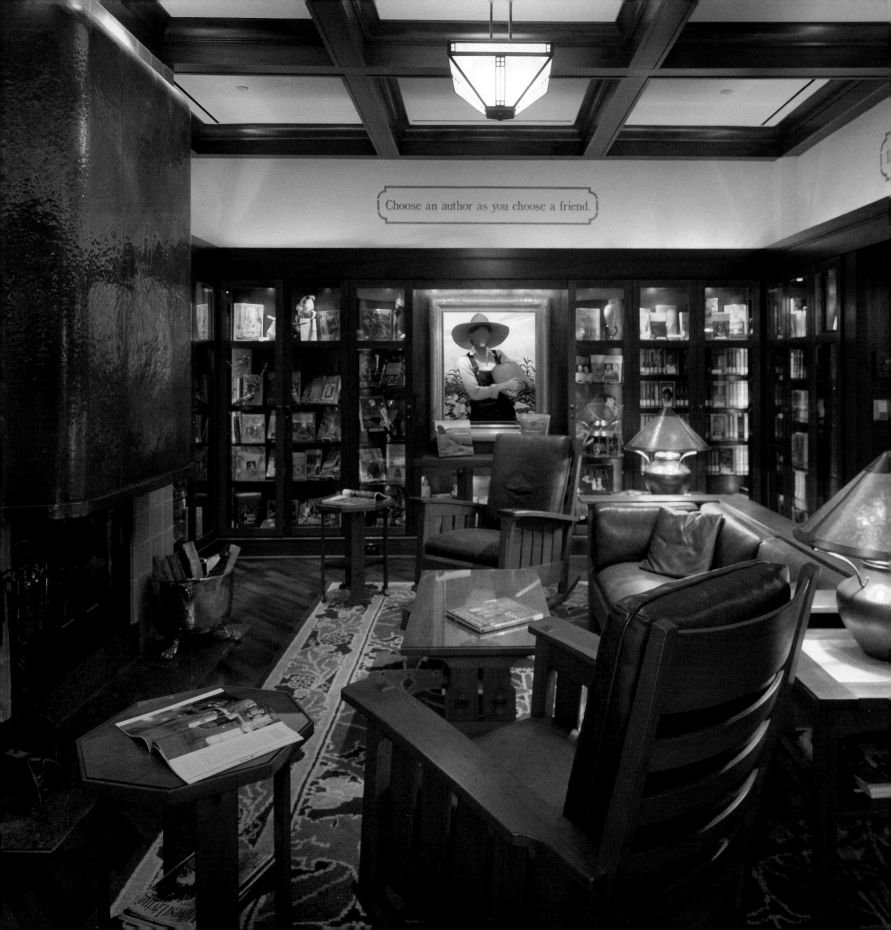

Choose an author as you choose a friend.

Dallas Willard is someone I like,
and he talks about God sitting out there
and exulting in the wonder of a star being born.
God is creating this wonderful thing
because He loves it. That same creativity
is written in who we humans are,
because we are made in God's image.
And I'm no different from anyone else.
I need to be creating something, too.
And the Hotel Pattee is something that
came out of my creativity.

— Roberta Green Ahmanson

David Kreitzer, *Two Sisters,* 1992
Watercolor on board | 39 x 29 inches

By hosting conferences, seminars, art exhibits, and perform-ances, the Hotel Pattee continues to honor art and artists from around the world. The Hotel has sponsored the "Uniting the Useful with the Beautiful" conference, which examined the ideas behind the Arts and Crafts Movement, and a three-day needlework seminar taught by Elizabeth Elvin, the director of England's Royal School of Needlework. An exhibition entitled "Color of Spring" featured the paintings of Hawaiian artist Jan Kasprzycki, and the Hotel annually displays the work of stu-dent artists from Perry, Iowa.

The Hotel Pattee's artistic commitment is not limited to the visual arts. The Lamb's Players Theatre Group of San Diego, California, appear annually at the Hotel in a musical perform-ance of "A Hometown Christmas," written especially for the Hotel Pattee. Concerts by Anne Murray, Les Brown and his Band of Renown, Pat Boone, Jars of Clay, swing musicians Justin and Smitty Miller, and jazz great Abraham Laboriel have also been presented.

In the future, the Hotel plans to present a collection of Russian fine art; an exhibition featuring the work of Grant Wood; and an exhibit of immigrant art, representing the work of the diverse people who make up small-town America.

"As a child," Roberta Ahmanson recalls, "I was always arranging and rearranging the pictures that hung in our home. I need to be creating something, too, and the Hotel Pattee is something that comes out of my creativity. Today, I want guests to be able to come in and see art on the walls of the Hotel. I want them to be able to celebrate life through art."

Hotel Pattee

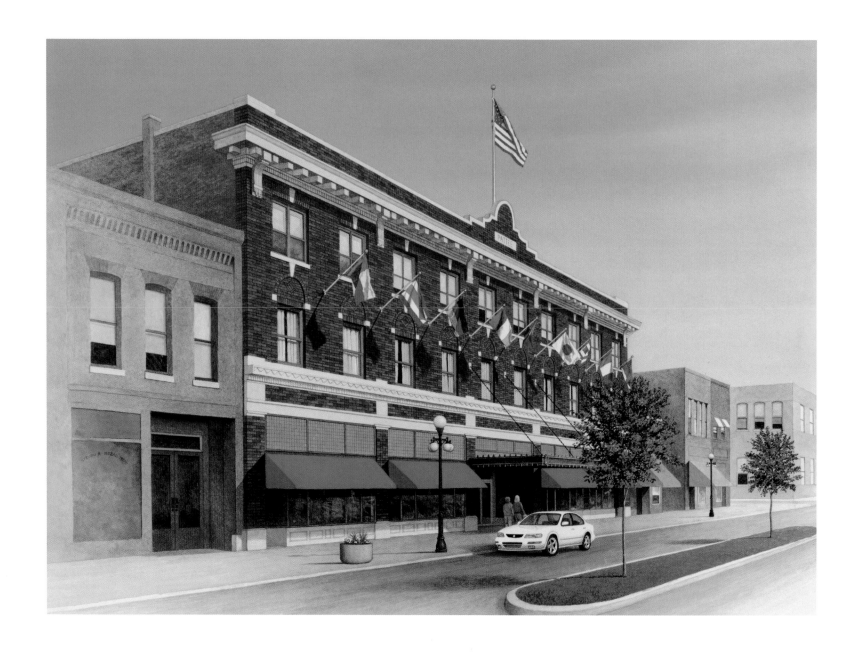

First Floor

Second Floor

Lower Level

Third Floor

GARY ERNEST SMITH

NOTE: Italic page numbers indicate a photo.

Page 14: Gary Ernest Smith, Hotel Pattee lobby, *Canning,* 1995
Oil on canvas | 36 x 60 inches

Page 28: Eric Peterson Bowl, Hotel Pattee lobby fireplace

Page 32: Mac Hornecker, *Tornado Struck,* 1995
Steel | 24 x 85 inches

Page 62: Doug Shelton, *Midwest Rails,* 1997
Oil on canvas | 25 x 60 inches

Page 132: Adam Madebe, *Bushman,* 1998
Steel | 31 inches high

Page 156: Steven Kozar, *Hotel Pattee,* 1996
Watercolor on paper | 12.5 x 18 inches

Page 158: Gary Ernest Smith, *Red Barn with Workman,* 1994
Oil on canvas | 36 x 36 inches